Mastering
Digital Flash
Photography

Mastering
Digital Flash
Photography
The Complete Reference Guide

Chris George

LARK BOOKS
A Division of Sterling Publishing Co., Inc.
New York

Mastering Digital Flash Photography
The Complete Reference Guide

Library of Congress Cataloging-in-Publication Data

George, Chris M.T.
 Mastering digital flash photography : the complete reference guide / Chris
M.T. George. — 1st ed.
 p. cm.
 Includes index.
 ISBN-13: 978-1-60059-209-6 (pb-with flaps : alk. paper)
 ISBN-10: 1-60059-209-0 (pb-with flaps : alk. paper)
 1. Electronic flash photography. 2. Photography—Digital techniques. I.
Title.
 TR606.G47 2007
 778.7'2—dc22
 2007015988

10 9 8 7 6 5 4 3 2 1
First Edition

Published by Lark Books, A Division of
Sterling Publishing Co., Inc.
387 Park Avenue South, New York, N.Y. 10016

© The Ilex Press Limited 2008
© Images Chris George 2008

This book was conceived, designed, and produced by:
ILEX, Cambridge, England

Distributed in Canada by Sterling Publishing,
c/o Canadian Manda Group, 165 Dufferin Street
Toronto, Ontario, Canada M6K 3H6

If you have questions or comments about this book, please contact:
Lark Books
67 Broadway
Asheville, NC 28801
(828) 253-0467

Manufactured in China

ISBN 13: 978-1-60059-209-6
ISBN 10: 1-60059-209-0

For more information on Mastering Digital Flash Photography, see:
www.web-linked.dflaus.com

For information about custom editions, special sales, premium and corporate purchases, please
contact Sterling Special Sales Department at 800-805-5489 or specialsales@sterlingpub.com.

Introduction

In some ways, flash lighting has become less essential since the arrival of the digital camera. This is not because digital image sensors are better at "seeing" in the dark than film, but because digital cameras are so eminently adaptable to a wide variety of light sources. Their white balance systems mean they can produce a picture with accurate coloration no matter what type of lightbulbs are being used in a room. There is no need to worry about filtration—the camera does this for you. What's more, you can check for unexpected color casts after each shot, and adjust the white balance manually if necessary. The result is that it is easy to shoot pictures for which flash was once essential. Often, all you need is a tripod, a long shutter speed, and a conveniently placed window or desklamp.

Despite this, flash has not just survived the digital era, it has flourished. A flash unit is built into practically every camera you buy—even many high end SLRs offer a pop-up flash as well as a hotshoe. Furthermore, there is a healthy market in ever-more sophisticated external flash units, and a myriad of accessories that modify the light to tackle a wide variety of photo opportunities.

However, it is clear that the rules of engagement have altered. Flash remains an invaluable photographic tool, but its role has changed subtly. It is still the artificial

VISUAL FEEDBACK
A digital camera's LCD screen means you can confirm you have caught the perfect shot. High-speed shots of splashes once required specialist equipment, but with a digital camera you can simply keep shooting until you succeed.

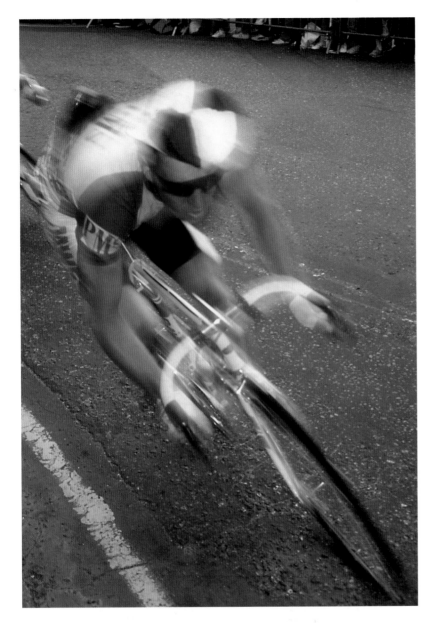

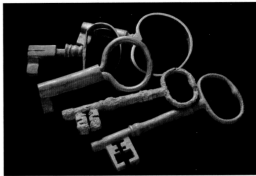

RECREATING DAYLIGHT

Flash photography is often about lighting the scene as if it were lit by sunlight. But the lengths to which you have to go to modify the flash lighting may sometimes mean that it is simpler to use sunlight in the first place. These rusty keys were lit by setting up a table near a convenient window.

SENSE OF SPEED

Flash can be useful even in situations where you might not think it necessary. Combined with a slower shutter speed, the mix of flash and sunlight in this action shot creates the impression of movement.

lighting source of choice for a wide variety of studio subjects, and particularly those that cannot remain still for long exposures. The brief exposures that flash allows is ideal for portraits, but the speed of operation means that flash may also be used for any other subject as well.

For the film photographer, flash was often a necessary evil; you needed it, but getting a carefully balanced exposure was never straightforward. There

was always a risk of unwanted shadows and burnt-out highlights in one or more areas of the image, and no way of seeing this until you had your film developed.

The advantage that the digital user has is the ability to get almost instant feedback. You can check for problems on the camera's LCD screen and take corrective action. Age-old problems such as bleached-out foregrounds, red-eyed portraits, and dark backgrounds all remain, but you get an opportunity to see the problem and remedy it before it is too late.

This visual feedback is not just useful for straightforward shots. The LCD's guiding hand means you can afford to be more experimental and adventurous with the flash. You can mix long exposures with flash and see immediately whether it is worth persisting with the technique. Flash tricks that were once left to the specialist, such as high-speed photography can now be tackled confidently with the minimum of equipment or stress. Since taking another set of shots costs nothing, the digital photographer can keep shooting until they get the exact result they were looking for.

This book is designed to show you how to exploit flash fully with a digital camera.

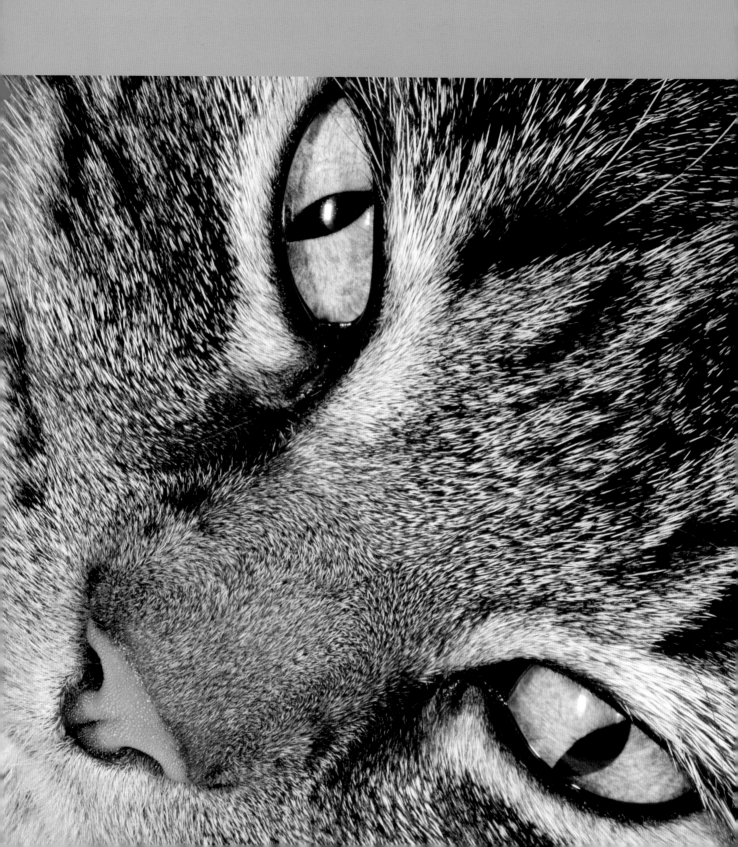

Chapter One
THE BASICS

The Physics of Light

Light is a form of electromagnetic radiation, most commonly produced by thermal sources such as the sun, light bulbs, flames, and so on, but it can also be caused by a variety of other processes including phosphorescence (the re-release of previously absorbed energy), chemo- or bioluminescence (the production of light through chemical or biochemical mechanisms), and a whole variety of other processes. Visible light is only a small part of the electromagnetic spectrum, covering wavelengths of between 400 and 700 nanometers, where a nanometer equals one billionth of an inch. The color of this light ranges from violet, through blue, green, yellow, and orange, up to a wavelength of around 700 nm, which is a deep red. Light with a wavelength between 250 nm and 400 nm is classed as ultraviolet, and light with a wavelength longer than 700 nm is termed infrared. These very short and long wavelengths are beyond the visible spectrum.

While the human eye can only detect a small segment of this spectrum, photographic materials are more sensitive and can "see" a larger range. Film, for example, is sensitive to ultraviolet light, and most modern digital cameras use an infrared blocking filter because pixels are sensitive to this kind of invisible light.

It's also worth noting that although the spectrum of visible light is continuous—in that there is a smooth and continuous transition throughout the range—the human eye is relatively poor at detecting color. We tend to see color in three broad ranges: blues, greens, and reds. An important consequence of this limited ability to detect color is that we can combine these three ranges of color to produce other colors. For example, we can add red and green light, and instead of seeing both, we perceive the light to be yellow. Likewise, when we add all three color ranges together we perceive the result as white. Digital cameras utilize this knowledge to good effect, with sensors typically comprised of a set of photodiodes, filtered to accept red, green, or blue light. This data is combined to provide an RGB value for each sensor site or pixel.

HOW DIFFERENT LIGHT SOURCES COMPARE ALONG THE COLOR TEMPERATURE SCALE

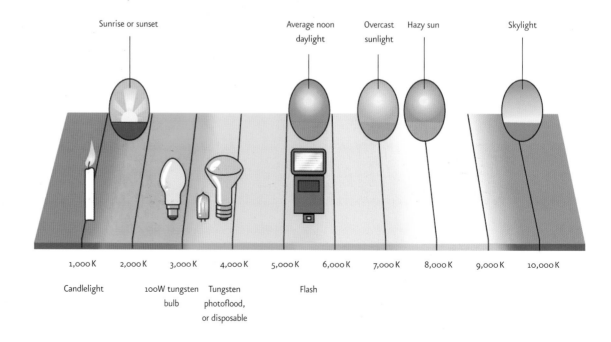

Sunrise or sunset — Average noon daylight — Overcast sunlight — Hazy sun — Skylight

1,000 K 2,000 K 3,000 K 4,000 K 5,000 K 6,000 K 7,000 K 8,000 K 9,000 K 10,000 K

Candlelight 100W tungsten Tungsten Flash
 bulb photoflood,
 or disposable

Color temperature

While a digital camera records the color of light in terms of the relative intensity of the red, green, and blue components of the light hitting a particular sensor site, we can also measure what is termed the "color temperature" of a scene or light source. Color temperature refers to the overall color of the light illuminating a scene, such as the orange light of a sunset or the cool blue of the midday sun. It is measured in degrees Kelvin (K) and natural sources of light range from around 1,500 K (a flickering match flame), through 5,500 K (natural daylight and most electronic flash units), to 10,000 K and above (the blue light scattered by the atmosphere). Color temperature can be measured using a variety of devices including spectroradiometers and spectrophotometers (that measure the amounts of each of the component colors in the spectrum of a light source at very precise wavelengths, generating a characteristic "fingerprint" of the light source), colorimeters that measure the color balance of an image, and color temperature meters such as the Gossen Color Pro 3F Color Meter that measure the Kelvin value of flash or ambient light.

It's worth noting that the temperature of a light source, and our expectations of which colors correspond to which temperatures, don't match; i.e. cool light sources are red whereas very hot ones are blue. This is because color temperature is determined by comparing the hue of a light source to a heated black body radiator (a "black body radiator" is an object that doesn't reflect light or allow light to pass through it). Below 700 K (about 800° F) a black body produces very little visible light, but beyond this temperature it starts to glow red, going through orange, yellow, and white, before turning blue as the temperature approaches 7,000 K (around 12,140° F).

To slightly complicate matters, some light sources behave much like black body radiators, while others don't. An incandescent light source such as a tungsten lamp, for example, emits radiation in much the same way as a black body radiator. A fluorescent lamp, on the other hand, does not produce radiation/light in the same way and is assigned what is termed a correlated color temperature (CCT) instead. This is the color temperature of a black body radiator that most closely resembles the lamp's perceived color.

It's also worth noting that we can't perceive color temperature as accurately as a camera or color meter records it. For example, if you use the camera's "daylight" white balance setting in a room that's lit by an incandescent light source such as a table lamp, the resultant photograph will have a very obvious orange cast, even though the scene doesn't appear orange to your eyes. This is because incandescent lights, such as a tungsten lamp, have a color temperature of around 2,800 K, while a camera set to daylight mode assumes that the average color temperature of the scene is 5,500 K, and records the colors accordingly.

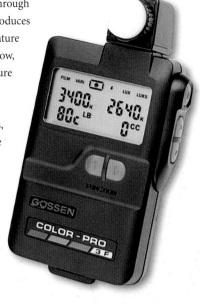

GOSSEN COLOR-PRO
A color meter measures the color temperature of flash or continuous light, as well as providing a read out of the light's brightness, or luminance.

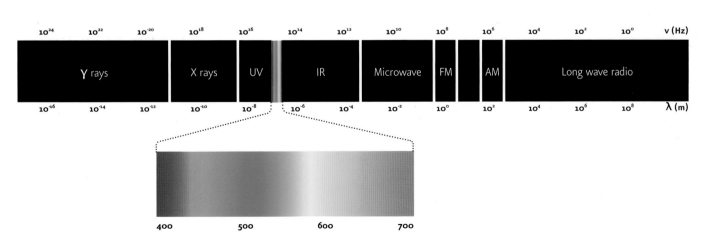

White balance

In the simplest sense, altering the white balance of an image is a way of removing color casts so that naturally white and neutral objects within a scene are rendered as naturally white and neutral in the resulting photograph. More often than not, such alterations won't be necessary as a digital camera's automatic white balance (AWB) system will do a pretty good job of calculating the white balance. But at other times such systems will fail to produce accurate results and in these circumstances you have a number of options, at least when shooting an image that doesn't require additional flash.

Prior to taking the shot you can choose a white balance setting that more closely resembles the ambient lighting, such as cloudy, shade, daylight, fluorescent, tungsten, and so on. You can also set the white balance by taking a reading off a white or gray card, or, with the majority of DSLRs, you can choose a Kelvin value that matches the ambient light. The latter approach is best used in conjunction with a color meter, but it's worth bearing in mind that some light sources, such as fluorescent lamps, or other light sources with a correlated color temperature, produce light with a distinct color cast. In these cases it is often better to set the white balance manually using a custom setting.

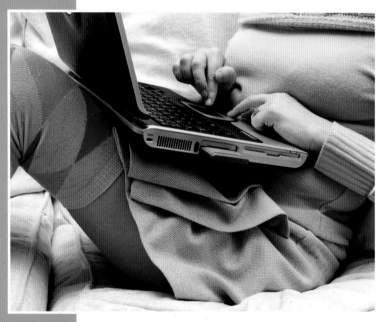

Correct white balance

After taking a shot, especially when shooting in the Raw file format, you can correct the white balance when you process the file. You can do this by using the white balance tool to select an area of the image that should be either white or neutral. This will not only adjust the color temperature of the image, but also adjust the "tint" in terms of its Green/Magenta shift. In ordinary daylight, no matter how cold or hot, the Green/Magenta adjustment won't be necessary, but if the main source of light is fluorescent lamps, the image may well have a distinctly green cast. The white balance tool will add more magenta to the image, thereby rendering the white and neutral areas correctly.

Most Raw conversion software will also have a color temperature slider that lets you adjust the temperature of an image, as in the examples shown here. The first (top right) is the original shot, and as you can see it appears far too warm. In the second shot (bottom right), the correction has been taken too far, and the image appears very cold. In the final image (below left), the neutral areas—the grays and blacks of the laptop computer, and the slightly off-white sofa—appear much more natural.

For more precise control over the white balance of a scene, especially when the original scene doesn't contain any white or neutral areas, you can shoot a test shot that includes a neutral gray card. The test shot can then be used to color balance any subsequent shots taken under the same lighting conditions.

Most electronic flash units produce light with a color temperature between 5,000 K and 5,500 K, which is much the same temperature as midday sunlight. When the color temperature of the flash matches the color temperature of the ambient light the only color correction you need to make to an image is a global one, meaning you can adjust the white balance of the image as a whole. On the other hand, when the color temperature of the ambient light differs significantly from that off the flash unit, color balancing an image can be more problematic. There are two solutions here; one that can be applied as the shot is taken, and the other applied during post-production.

The first involves adding a filter in front of the flash to alter its color temperature or to more closely match the ambient lighting. For example, Gary Fong produces an amber colored dome for his Lightsphere diffuser that results in a much "warmer" light, ideal for shoots at sunrise and sunset or

White balance too warm

when the ambient light is primarily tungsten based. This is a technique that is particularly suited to studio work, or in circumstances where you have sufficient time to evaluate the various light sources that will illuminate your image before taking the shot.

For those occasions where you don't have either the time or the means to correctly evaluate the ambient lighting you can color correct an image during post-production by selectively altering specific areas of the image. For example, if your photograph was lit by a combination of flash and fluorescent light some areas of the image will probably have a distinctly green cast. This can be fixed by selectively masking the flash-lit areas of the image and color correcting the remainder. This can be time-consuming, and is often problematic, especially in the areas of an image where the light sources interact (i.e. where the lighting is a combination of both flash and ambient light), but it will ensure that the final image more closely resembles the actual scene.

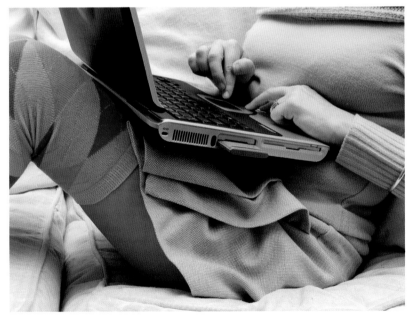

White balance too cool

WHITE BALANCE

Adjusting the white balance can have a dramatic effect on an image, as demonstrated by the original (top), and two attempts at restoration (above and far left).

ORANGE GLOW

The orange color of the background in this picture is caused by this area being lit by ambient hall lights, not by the flash, which only illuminates the foreground. The camera can only filter correctly for one of the light sources, but the resulting visual effect is pleasant.

The inverse square law

In addition to recording the color of an object, a camera must also capture the intensity of the light reflected from that object. Typically, a digital sensor has an exposure latitude that is similar to slide film—an exposure range of around five to six stops, where a "stop" refers to a halving or doubling of the amount of light hitting the sensor. For example, the difference between a ½ sec and one second exposure represents one stop, as does the difference between $f2.8$ and $f4$, or $f4$ and $f5.6$, and so on. In practice, this means the dynamic range of a camera's sensor is sufficiently wide to cover a range between the brightest area of an image and an area that is only 1/32 as bright (for a five stop range) and 1/64 as bright if we assume a six stop range.

When we start to consider using artificial light sources to supplement the naturally available light in a scene there is a further complication that we must consider, which is typically referred to as the "inverse square law." This law states that the intensity of a light source is inversely proportional to the square of the distance from the source of the light. In simple terms, this means the amount of light falling on an object decreases the farther away it is from the source of the light, but at a greater rate than you might expect. For example, you might imagine that an object two yards away from a light source would receive half the amount of light to an object only one yard away, and that an object four yards away would receive a quarter of the light. However, this isn't the case.

An object two yards from the source receives only a quarter of the light falling on the object one yard away (the square of the distance ÷ 2 yards × 2 yards = 4), while an object four yards away receives only a sixteenth of the light (4 yards × 4 yards = 16).

In practical terms, this means the light from any artificial source—a flash unit, a studio light, or a standard light bulb—falls away very quickly as the distance from the light to the subject increases. This effect can be seen quite easily when you use an on-camera flash as the primary source of illumination, with people or objects in the foreground appearing relatively well lit, but objects or people further away very dark in comparison. If we relate this to the dynamic range of a camera's sensor we can

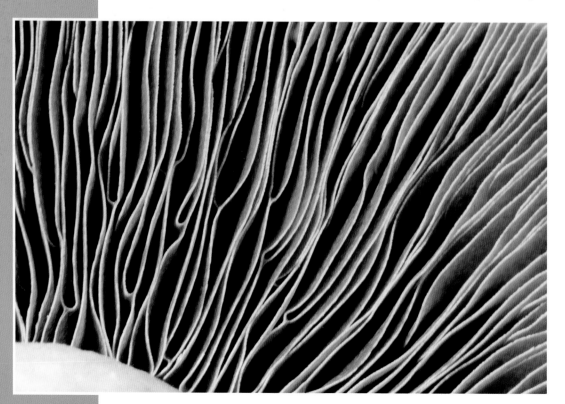

POWER TO STOP DOWN

With macro shots, a small aperture is essential if you are to get enough of the subject sharp. For this close-up of a mushroom, an aperture of $f32$ was used, requiring the diffused studio flash to be set to a relatively high power setting.

see that if we set the flash to correctly illuminate an object one yard from the camera, and there are no other sources of illumination, an object only seven yards away will receive insufficient illumination to fall within the dynamic range of your camera's sensor. In other words, the object seven yards from the camera will receive 1/49 of the light striking the object one yard away. This level of illumination may well fall outside the digital camera sensor's dynamic range.

Guide numbers

Flash power for a portable flash unit is measured using a Guide Number (GN) that is given in either feet or meters. Higher guide numbers denote greater power, which means you will be able to successfully illuminate a subject that is further from the camera.

The standard for measuring a guide number is based on the effective maximum range of the unit if you were using a lens set to an aperture of $f1$. Therefore, if you had Canon's legendary EF 50mm $f1.0$L lens and used it with a flash with a guide number of 92 ft, it could theoretically allow you to take pictures of a subject 92 ft (or 28 m) away using the maximum aperture

However, this is obviously an exceptionally fast (not to mention expensive) lens, and most of today's optics, especially zooms, have a maximum aperture of $f2.8$. This doesn't mean a guide number is simply an arbitrary term though, as you can still work out the maximum range of a flash by dividing the guide number by the actual aperture you are using. So, if you were using an aperture of $f4$, for example, a flash with a guide number of 92 ft would have a maximum range of 23 ft (7 m). Stop down to f16, and the range would be a little less than 6 ft (or 1.8 m).

Of course, the actual range of the flash is dependent on other factors, most notably the focal length and ISO sensitivity you are using. Just as increasing the ISO will allow you to use a smaller aperture in daylight conditions, so a high ISO will also allow you to get more "reach" from your flash. The guide number measurement is usually based on an ISO 100 setting, but you should always doublecheck the specification of a flash as some manufacturers have been known to base the guide number on an ISO 200 setting, which will make the unit appear 1.4x more powerful.

Maximum range and guide numbers					
Guide number of flash (ft/ISO 100)	(m/ISO 100)	ISO setting used	Aperture used $f4$	$f8$	$f16$
39	12	100	10 ft (3 m)	5 ft (1.5 m)	2.5 ft (0.75 m)
39	12	400	20 ft (6 m)	10 ft (3 m)	5 ft (1.5 m)
39	12	1600	40 ft (12 m)	20 ft (6 m)	10 ft (3 m)
92	28	100	23 ft (7 m)	11 ft (3.5 m)	5.5 ft (1.7 m)
92	28	400	46 ft (14 m)	23 ft (7 m)	11 ft (3.5 m)
92	28	1600	92 ft (28 m)	46 ft (14 m)	23 ft (7 m)
184	56	100	46 ft (14 m)	23 ft (7 m)	11 ft (3.5 m)
184	56	400	92 ft (28 m)	46 ft (14 m)	23 ft (7 m)
184	56	1600	184 ft (56 m)	92 ft (28 m)	46 ft (14 m)

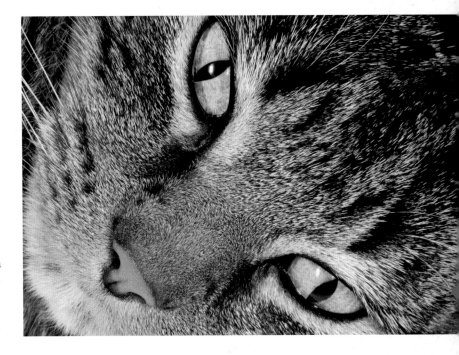

It is also worth checking the focal length that the manufacturer has based the guide number on. In the days of 35mm SLRs the measurement used to be based on a 50mm "standard" focal length (and ISO 100), which made comparisons between flash power straightforward. This is still largely the case, but some flash makers have started quoting guide numbers based on an 85mm focal length instead. While this isn't wrong, it makes comparisons between flash units a little harder as the longer the focal length the more "powerful" a flash appears to be.

MINIMAL OUTPUT
A specialized macro flash was used for this cat close-up. Set to 1/8 of its maximum power, the effective guide number was around 7 ft @ ISO100, (or 2 m @ ISO100).

Flash basics

As the little symbol on your camera suggests, flash lighting is a bit like lightning—a brief, intense burst of light is created from thin air. But unlike nature, the flash's "bolt of lightning" is highly controlled, and can be produced again and again upon demand.

A flash works by sending a high electrical charge through a gas, releasing a brilliant burst of light. The gas used is xenon, one of the "noble" gases—chemical elements that do not react easily with other substances. One of the reasons that xenon is used, rather than any other gases,

is that the mixture of wavelengths of light emitted closely resembles the color balance of normal daylight. The gas is contained in a sealed glass tube and hidden behind a frosted plastic window on the camera or flash unit. This "window"—or diffuser—serves to protect the delicate tube and spread the light evenly across the scene.

The job of the flash is made more complicated in that it needs to produce electricity with a high voltage—typically over 300 volts—to "ignite" the xenon gas. To do this with a handful of 1.5 volt pen cells, or even the AC current used

Capacitor
This is the electrical "bucket" that stores the high voltage charge created by the flash unit. When the capacitor is full, the flash is ready to fire.

Diffuser screen
Sits in front of the flash tube, spreading the light from it to make the coverage more even.

Power
The power for portable flash units usually comes from pen (AA) cells. The more powerful the unit, the more batteries that are generally used. The type of battery used will affect the recycling time and the maximum number of flashes.

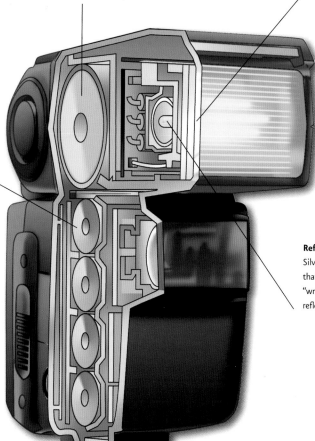

DANGER! HIGH VOLTAGE!
Although they may only be powered by low-voltage batteries, flash units should not be taken apart by those who do not know what they are doing.

A charged capacitor could give you an electrical shock that you will not forget in a hurry, and under the wrong set of circumstances the high voltage could even prove fatal.

The capacitor can retain its charge even when the unit is switched off.

Reflector
Silvered surface behind the flash that ensures light heading the "wrong" way from the tube is reflected toward the subject.

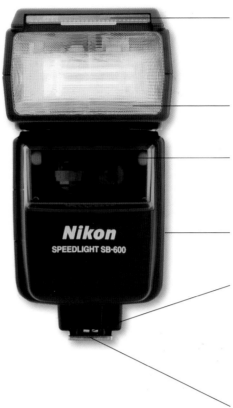

Wide-angle adaptor
Supplementary diffusion panel to
increase coverage of the flash to
match wide-angle focal lengths.

Diffuser panel
Protects the flash tube,
and diffuses the light.

AF illuminator
Provides a patterned light
source to aid focusing in
low light conditions.

Battery compartment cover
(on side)

Hotshoe contacts
These make an electrical
connection with contacts on
the top of the camera. They
synchronize the flash with
the shutter, and control other
"dedicated" features.

Foot
Physical means for connecting
flash unit to the hotshoe of the
camera, and ensures correct
alignment of electrical contacts.

LCD panel
Displays information about
flash settings.

Flash ready light
LED indicator tells you when
the capacitor is full, and the
flash is ready to fire.

Control buttons
For changing flash settings.

Foot lock
Locks foot onto hotshoe
to prevent it slipping off.

by studio flash units, requires the use of an internal
transformer to step up the voltage to the required level.
It is this that makes the audible whistling noise you
hear as the flash charges up.

The high-voltage charge produced by the transformer
is placed in a temporary store called a capacitor. When
the capacitor is full, the flash is ready to fire.

However, the xenon gas needs a helping hand if it
is to conduct the voltage that has been created. This is
the job of a coil around the tube containing the xenon
gas, which creates a brief burst of electrical current to
ionize the xenon atoms, exciting them enough so that
the stored voltage from the capacitor can arc across
the tube, producing the chain reaction that creates the
photons of light—or "flash."

The flash lasts for just a fraction of a second—
typically less than 1/1,000 sec—until the charge from
the capacitor has been exhausted. With most electronic
flash units, the duration of the flash can be controlled,
with a thyristor circuit cutting off the voltage to the
tube when enough light has been created. This saves a
proportion of the capacitor's power, so that it recharges
more quickly. It also means that the flash duration can be
reduced to less than 1/40,000 of a second.

Controls

Other than when shooting in a studio, or under circumstances where the ambient light is so low that it won't significantly affect the final exposure, flash is employed to balance the ambient light with the light from the flash unit, either to produce a more natural looking shot—the removal of harsh shadows from a person's face, for example—or to produce a shot that more closely matches your creative expectations. There are a variety of ways in which this can be achieved; either by altering your camera settings (aperture, ISO, and shutter speed), or changing the settings on your flash, such as power output (when operating the flash manually), or flash exposure compensation (FEC) when using it automatically.

• Aperture

Altering the aperture at which a shot is taken affects the way in which the camera records both the ambient light and illumination from a flash unit. An aperture of $f2.8$ will allow twice as much light to reach the sensor as an aperture of $f4$ at any given shutter speed. In this sense, the aperture you use for a shot has no impact on the balance between the ambient light and light from your flash unit, it simply controls how much light reaches the sensor from either source. Shooting at a wider aperture allows more light to reach the sensor, while a smaller one permits less.

• ISO

Likewise, altering the ISO at which a shot is taken doesn't affect the balance between the ambient light and light from the flash unit. However, given that most flash units are relatively weak compared to natural sources of light, altering the ISO can be a useful technique, especially if you don't want to shoot at a wider aperture. For example, if you were taking a portrait with a 200mm lens, you might not want to shoot at an aperture wider than $f5.6$ (to ensure that all the subject's features are in focus), nor lengthen your shutter speed (and risk motion blur or camera shake). If your flash unit is insufficiently powerful to shoot at this aperture, upping the ISO would mean that you could get the shot without compromising other aspects of the image, save for the potential appearance of "noise" (image grain) as the sensitivity setting is increased.

• Shutter Speed

Unlike alterations made to the aperture or ISO, altering the shutter speed (to a value that does not exceed your camera's maximum sync speed) can alter the balance between the ambient light and light from your flash unit, but only when the flash is providing the main source of illumination for a foreground element. When using digital TTL flash metering, your camera will automatically balance the output of your flash unit to the ambient light, but when shooting with a manual power setting, the flash unit's output is predetermined.

What this means is the flash will provide the main source of illumination for the foreground element, and due to the fact that the duration of the flash will be considerably less than the shutter speed, altering the shutter speed will make no difference to the level of illumination of the foreground element. It will, however, affect the amount of ambient light reaching the sensor. In other words, altering the shutter speed will affect the balance between the ambient light and the light from your flash unit—a longer shutter speed will increase the amount of ambient light, while a faster shutter speed will minimize the effect of the ambient light. In this way you can balance the ratio between the flash and ambient lighting, to give greater or lesser dominance to one or the other.

• Power Output

All studio-based flash units, and a good proportion of dedicated flash units allow you to alter the power output of your flash unit when using the flash in manual mode. Canon's 580EX II, for example, allows you to set the power output between full power and 1/128 of that power, in 1/3 stop increments. This gives you very precise control over the balance between the ambient light and the light from your flash unit, but of course requires you to be working in manual mode, or employ flash exposure compensation if the camera or flash has it.

• Flash Exposure Compensation

When using your flash unit in automatic mode, the camera will attempt to balance the ambient lighting with that from your flash. Generally, modern flash control systems

will produce very good results, but there will be times when it's worth overriding the camera's settings—either because your camera's metering gets it wrong, or you want to alter the balance between the two light sources for creative effect. For example, when using fill-flash for portraits on relatively overcast days you may find that your camera/flash adds a little too much flash, leaving you with a photograph that doesn't look especially natural. In these circumstances you can decrease the flash output—typically in 1/2 or 1/3 of a stop increments—by using flash exposure compensation. This doesn't affect the amount of ambient light reaching the sensor, but lessens the effect of the flash, making it appear less obvious in the shot.

Head angles
The flash-head clicks into place at certain pre-determined angles, marked here.

Flash exposure compensation
Instructs the flash to emit more or less power than it would normally. Adjusted in fractions of an EV.

E-TTL
This indicates this Canon 580EX II unit is mounted on an E-TTL-enabled Canon camera. The flash can use data from its focusing system to determine how far away the subject is. This gives the flash an idea of how much power is likely to be needed to create a good exposure at the aperture set on the lens.

Zoom setting
Displays the zoom position of the flash head, usually to match the position of the lens, but can be set independently.

Distance scale
This bar shows the range of distances over which the flash will be effective at the currently set aperture, ISO and zoom head position.

Mode button
Controls the main mode of the flash; generally to switch between manual output, E-TTL and high speed sync modes.

On/off switch
Sliding this switch has near-instant effect.

Wireless multiple flash control
Switch the flash to Master to control other units wirelessly, or to Slave for this unit to be controlled by another

Control dial
Used in conjunction with the buttons to adjust settings.

Shutter synchronization

Flash synchronization, also referred to as flash sync (or "synch"), refers to the process where the production of an electronic flash unit's light is synchronized with the operation of the camera's shutter so the burst of flash is recorded by the camera. There are four basic forms of synchronization—first curtain sync, second curtain sync, slow sync (which can be used in conjunction with either first or second curtain sync) and high-speed sync. Before discussing these in any detail we first need to understand how a camera's shutter works.

DSLR's utilize a focal plane shutter, which is a pair of mechanically operated blinds or curtains, that open and close to regulate the exposure. As you press the shutter release the first blind opens, exposing the sensor. The second blind then follows, thereby closing the shutter.

Because these blinds can only travel at a finite speed, the second blind begins to close before the first blind has finished opening when very short shutter speeds are used, exposing the sensor to a slit of light. The faster the exposure, the narrower the slit of light. The point at which the shutter begins to operate in this way is referred to as the camera's "sync speed," which is typically around 1/200 to 1/250 of a second. This sync speed is the fastest shutter speed during which both blinds are fully open at some point—no matter how brief. Because the burst of light from an electronic flash unit is often very short (a typical duration for a camera-mounted unit would be around 1/3,000 of a second), at shutter speeds higher than a camera's sync speed the sensor only receives a narrow band of light because both blinds are never fully open.

1/200 sec

1/350 sec

1/500 sec

1/1000 sec

SYNC SPEED—1/200 sec
The maximum shutter speed possible with flash on the digital SLR used in the examples here is 1/200 sec.

FASTER SPEEDS
At shutter speeds faster than the sync speed, more and more of the scene is masked by the shutter curtains. With this camera, at 1/1000 sec the frame is only lit by the dim ambient light, with no flash reaching the sensor, giving an almost jet-black frame.

High Speed Sync

High Speed Synchronization solves any sync speed problems by firing the flash continuously during an exposure—between forty and fifty thousand times per second. These pulses of light, while not as bright on their own, merge together, to make sure that all areas of a camera's sensor are illuminated during exposures that are faster than the camera's sync speed.

First or Front Curtain Sync

As mentioned, the duration of a typical burst of flash is normally considerably shorter than the shutter speed, and providing the flash fires at some point during the period both blinds are fully open, this will result in an evenly illuminated image. But at which point exactly should the flash be fired?

Most cameras default to firing the flash at the first point at which both shutter blinds are fully open, which is termed First (or Front) Curtain Sync. However, with slower shutter speeds, this can lead to odd looking shots. For example, if you shoot a person running left to right through your frame with a shutter speed of a few seconds, the resultant image will show a brightly illuminated person at the left of the frame (when the flash fires), and a trail in front of that person where they have been lit by the ambient light. As we are accustomed to perceive movement blur as something that follows an object, this can look unnatural.

Second or Rear Curtain Sync

To avoid this problem you can wait until the point immediately prior to the second blind closing before firing the flash (so the flash is synchronized with the second curtain). In the example above this would mean any ghosting caused by the ambient lighting would follow the person, as the main source of illumination now comes an the end of the exposure.

Though this provides more natural looking images, it isn't without its problems. With first curtain sync the flash fires almost immediately, allowing you to compose your image, trip the shutter, and fire the flash, to end up with a well composed shot. However, with second curtain sync you need to estimate where the

1/20 sec

1/2 sec

1/125 sec

SLOWER SPEEDS

Shutter speeds slower than the camera's sync speed can be used without any synchronization problems. However, the longer the shutter speed, the more the ambient light affects the exposure, as can be seen clearly in the coloration caused by the room lighting in the 1/2 sec exposure.

X MARKS THE SPOT

On some cameras, the maximum flash sync speed is known as the X-sync setting, and on older medium- and large-format cameras the shutter speed dial may even be marked with an X to show this.

The X setting was designed to distinguish it from the alternative M setting that was designed for use with flash bulbs. These disposable bulbs take longer than electronic flash to reach their peak brightness, so need a slower shutter speed. These days, flash bulbs only find use in cinema special effects, or for photographing large scenes where electronic flash would be impractical or easily damaged—they are used widely in caving photography, for instance.

subject will have moved to by the end of the exposure. For example, if you are photographing a person walking in front of the camera using a shutter speed of one second, the chances are they will still be in the shot by the time the flash fires. A cyclist riding past, on the other hand, will probably have left the frame entirely by the time the flash fires. As with any photographic technique, practice will ensure you can estimate the position of your subject, with respect to both its speed and the shutter speed you have chosen.

Dedication

Getting the flash to synchronize correctly with the shutter opening is not simply a matter of setting the right shutter speed—the two units also need to communicate with each other. At its most basic, the camera needs to tell the flash when to fire, but in reality most built-in and accessory flash units do far more than this. They also exchange information on their status to simplify the operation and to provide a whole range of information.

This two-way flow of information is known as "dedication," and relies on the two pieces of equipment speaking the same language. In the case of a built-in flash this is easy to ensure, but with a bolt-on unit it is not so straightforward. The electrical connectors used not only vary from manufacturer to manufacturer, but often from model to model as well. Furthermore, many aspects of dedication rely on the flash, the camera, or both, having particular features that may be missing.

The fact that a flash unit claims to be "dedicated" to a particular brand, therefore, is no guarantee that it will function perfectly with your particular camera. In addition, some forms of advanced metering not only require a compatible flash and camera but also demand

that you use the right generation of lens. That said, any accessory flash bought recently should be capable of the dedication required to achieve the full gamut of features. It is only with much older units that this might be a problem.

For add-on flash units, the camera commands and flash feedback are most usually communicated via electrical contacts in the hotshoe, which correspond to contacts on

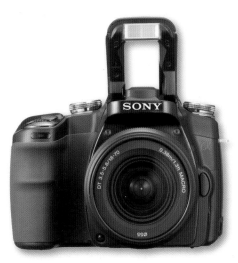

POP-UP DEDICATION
Being built in to the camera, a pop-up unit is the ultimate example of what dedicated flash can do. It will fully support all of the camera's flash based functions.

HOTSHOE STYLES
The hotshoe platform is the flash connection system found on SLRs and other high-end cameras. However, just because a flash fits the hotshoe, it does not mean you can use any flash to its full potential on any camera—the dedicated electrical connections need to be compatible, too.

Canon

Nikon/Fuji

Sony/Konica Minolta

Pentax/Samsung

Olympus

Kodak

AF ILLUMINATOR

An unexpected bonus of using an add-on flash unit is that it can make it easier to focus the lens accurately. Nearly all digital cameras use a contrast detection autofocus system. This essentially looks at the image to work out how to adjust the lens, using the premise that an in-focus image is more contrasty than an out of focus one.

If you are using the flash in near or total darkness there is no contrast for the AF to work with. What's more, you probably won't be able to see to focus the lens yourself.

Some cameras have an AF illuminator built-in to them, but those on add-on flash units are more powerful, and will help you focus more quickly. They typically beam a pattern of red light over the subject, which the autofocus mechanism can lock onto. This focus aid can usually be used even if the add-on flash is not switched on.

AF illuminators work very well, but the downside is that the illuminator only works over short distances, and it is not suited to candid portraits as the beam makes your presence obvious to your target.

TARGETED ASSISTANCE

A dedicated flash shines a pattern of red light on the subject when the light levels or subject contrast are too low for the autofocus system to work. The targets projected are often designed to shine on the areas of the frame used by a camera's multipoint AF system.

Without AF illuminator

With AF illuminator

the foot of the dedicated flash. Every hotshoe unit has at least one visible contact, which is the central sync connector that is used to trigger the flash, plus a hidden return connector that completes the circuit at the side of the foot/shoe. Unfortunately, even this universal connector does not ensure full compatibility, as many older units use a trigger voltage that may damage modern camera electronics. The other connectors provide a whole host of further "dedicated" functions, that may include:

- Adjusting the zoom head of the flash to match the lens being used.
- Sending the signal to extinguish the flash when enough light has reached the sensor.
- Controlling the pre-flash systems to measure the flash output needed.

- Providing in-camera indicators as to whether the flash is ready, or whether the subject was within flash range.
- Ensuring a suitable shutter speed is set for synchronization with the camera, and taking into account whether the High Speed Synchronization mode has been activated.
- Activating the autofocus assist light when the shutter release is partially pressed.

The position of these other connectors can vary widely, making it harder to find a dedicated unit for your camera. Despite this, you are not obliged to buy the flash made by the camera manufacturer. Third-party manufacturers make units in a range of hotshoe fittings, ensuring varying degrees of dedication with many popular models. Other dedicated features need no connectors at all, such as wireless flash control.

Coverage

When a flash unit fires it spreads its illumination over the scene in front of it. Obviously, the angles at which the light leaves the head are limited by the way the flash tube is set in the flash head. This means that the light is directed in a beam, and thus will not cover everything in a 180 degree arc in front of the camera. To make the most of the flash output, units with an automatic zoom head channel light into different width beams so if, for instance, a telephoto lens is being used, the zoom head of the flash will direct the output to the central area of the scene that is covered by the lens' angle of view. On the other hand, when a wide angle lens is used the flash will broaden its beam to cover far more of the scene, making sure that all parts in the wide angle picture are covered by the light.

Inevitably, flash units have a limit to the width of their beam, and extreme wide angle lenses may "see" a wider view than the flash is capable of covering. In this case you will find the corners of the picture have not received light from the flash and appear dark. This is called "cut-off" or "fall-off," as the flash's illumination has been cut off by the design of the flash head, or has fallen off as the flash-to-subject distance has increased at the edges of the frame.

It is important that you are aware of the maximum lens coverage of the flash you are using, and when extreme wide angle lenses are fitted you use the flash's wide angle diffuser if it has one. Most modern flash units cover the angle of view of focal lengths as wide as 28 mm (equivalent focal length), but with a diffuser this can be as wide as 17 mm.

The use of diffusers and zooming actions does have an impact on the brightness of the light that the flash is able to put out, though, and a diffuser will reduce the maximum amount of light that can be made to reach a subject ten feet away from the camera. Conversely, the telephoto setting of a zoom head flash may increase the output by

WIDE-ANGLE DIFFUSER
Zooming automatically, this flash unit can offer coverage wide enough to use a 24 mm equivalent focal length. Fold down the special diffuser, however, and the coverage can cope with a 20 mm effective focal length.

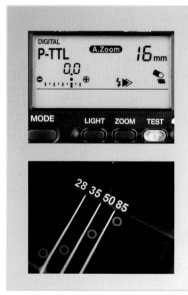

SENSORS AND ZOOM SETTINGS
With most modern flash units, the camera automatically zooms the flash to the correct position for the focal length in use, to ensure it covers the frame and the output is optimized in terms of power. The LCD on the flash (top left) shows it has been set to match a 16 mm focal length in this instance.

This is great if you're using the latest flash units, but if you want to use an older flash units it can be a problem. The manually controlled zoom head (bottom left) offers four coverage settings from 28 mm to 85 mm, but it's important to note that the focal lengths are based on 35 mm-format equivalents, not the smaller sensor sizes found in most digital SLRs. To get the best from this type of flash you should take your camera's focal length (FL) conversion factor into account before setting the zoom. For example, on a digital SLR with a 1.5x FL conversion a 28 mm lens setting will equate to a 42 mm focal length (in 35 mm-format). Use the zoom position on the flash that is closest to this effective focal length (42 mm), rather than the lens setting (28 mm). With this flash, the 35 mm position would be the one to use. It's important not to set the flash head to a longer focal length as the flash may not cover the entire frame.

focusing the light more. The basic guide number of the flash will remain the same, but the effective guide number will change according to how the flash is used. Manufacturers usually quote a guide number based on a zoom position suitable for use with a 50 mm equivalent focal length.

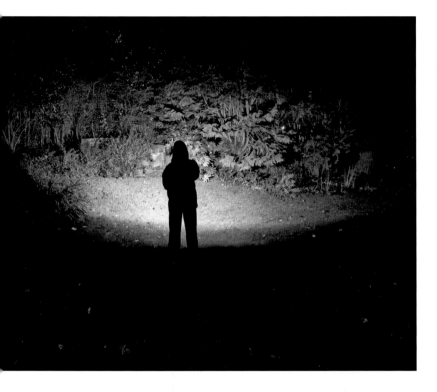

OWL IN A BARN

This shot of a sleeping barn owl shows no vignetting thanks to the use of a telephoto lens, that crops out any loss of light.

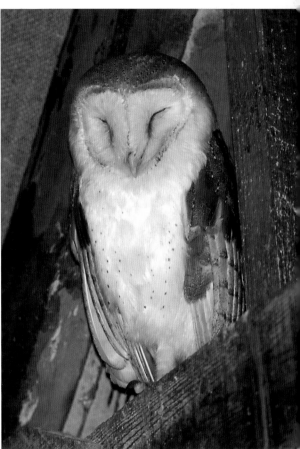

DROP IN THE OCEAN

It is important that you never forget that flash offers a very narrow field of coverage compared to daylight. You can see that clearly in the shot above. Taken with a 17 mm lens, the silhouetted figure manually fires the flash during a long exposure. You can see how little of the darkness the flash unit illuminates—and you can even see how the flash coverage falls off at the edges.

VIGNETTING

A stark example of the hotspots and vignetting created by flash. The shot is of an off-white wall, taken with a zoom lens set to an equivalent focal length of 27 mm. Contrast was not increased in post-production, but the built-in flash gives noticeably uneven coverage.

Flash metering

With modern flash systems there are two forms of metering you need to understand. The first—TTL (Through The Lens) metering—is conducted by your camera, with some assistance from the flash unit. The second involves the use of a dedicated flash meter to evaluate the flash output so you can set your exposure accordingly.

Before TTL metering

Prior to the advent of automatic flash metering, flash exposures had to be calculated manually. This was a laborious procedure, requiring you to know the flash-to-subject distance, the ISO, and the flash unit's guide number. Many flash units had a sliding scale on the back, which aided calculation of the "correct" aperture to set on the camera, but the whole process lacked any degree of fine

control and was prone to error, especially on transparency ("slide") film that requires great precision in the exposure.

The first automatic solution involved adding a sensor to the flash unit. Auto Flash Metering, as this was termed, involved setting the film speed and aperture on the flash unit, then triggering the shutter. Based on the information that you entered, a sensor inside the flash unit would measure the amount of light reflected by the subject and turn the flash output off when the desired amount of light had been received. However, this wasn't an especially accurate system as it did not work through the lens and had no way of reading or using the camera settings. It was a big improvement over earlier systems though, as you no longer had to take the flash to subject distance into account (providing this distance didn't exceed the range of the flash unit).

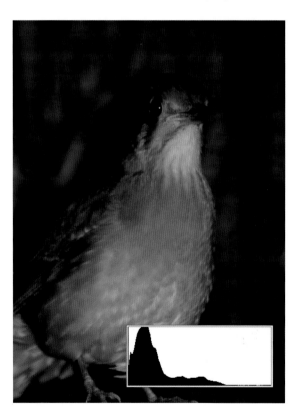

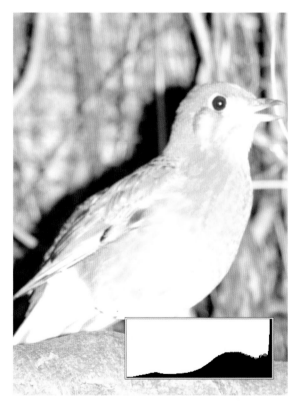

UNDEREXPOSED
The image is too dark. You can see this clearly in the histogram as the graph stacks up to the left.

OVEREXPOSED
The image is too bright. The histogram stacks up on the right of the image, and the exposure needs to be adjusted.

TTL metering

Through The Lens flash metering was developed by Olympus, and first appeared in their 35 mm OM2n SLR in 1975. Instead of the flash being metered by the flash unit, early TTL systems included a sensor within the camera body that measured the light reflected from the film plane. This was more accurate than earlier auto flash metering systems, as the earlier systems could be affected by light hitting the flash sensor, but not the film (or vice versa).

There were also two further benefits to placing the sensor within the camera. First, as the camera was providing the metering control, it didn't matter where the flash unit was placed with respect to the subject, so the flash unit could be positioned independently to the camera, rather than fixed on the hotshoe. Second, any filters attached to the camera wouldn't affect the metering, as the light was read after the light had passed through them.

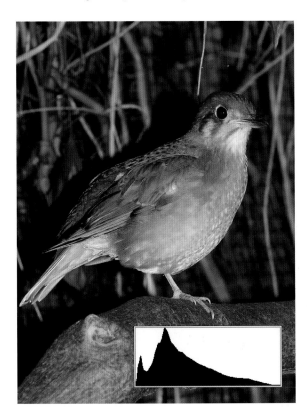

CORRECTLY BALANCED

A good flash exposure provides a graph that tails off nicely at the darkest and lightest ends of the graph.

ANALYZING EXPOSURE

Whatever flash metering systems your camera offers, and whichever one you use, you can't trust it to get a perfect result every time so you should check the exposure for yourself. It is all too easy for important parts of an image to be burnt out through overexposure, or for key elements to be lost in the shadows through underexposure.

Monitoring what is going on is easy—you simply take a look at the image on the LCD screen. However, while the playback screen gives you a guide, it still isn't reliable, so a far better method is to look at the image's histogram. This graph-like display shows the range of brightness in the image you have recorded. Every pixel is given a brightness value—from zero for the blackest black to 255 for the brightest white—and the results are then plotted on the graph.

A perfectly exposed image should show a graph with a range of tones stretching across all values, but falling away to nothing at both ends. An underexposed image will show a histogram graph that is bunched to the left, while overexposed images will have values that are pushed to the right.

This display may also give an indication of the areas of the image that will be "clipped," which are areas where detail will be completely lost due to overexposure or underexposure. Usually this is shown by flashing patches on the image itself on the LCD screen.

Unfortunately, many flash pictures will contain too much contrast for any exposure to capture both extreme highlights and shadows well. With digital imaging it is almost always better to have clipped shadows than clipped highlights, so the important thing to check is that the histogram is not stacking up hard to the right-hand side of the graph.

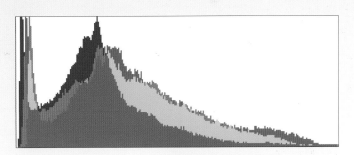

ALTERNATIVE HISTOGRAMS

Histograms are also available in modes that reveal each color channel separately, and are generally available straight from your digital camera's playback mode.

Digital TTL

As digital cameras no longer have a film plane to measure light from, digital TTL systems—such as Canon's E-TTL II and Nikon's i-TTL—utilize the image sensor itself to gather information. These systems utilize a brief pre-flash, fired before the main flash, which is metered by the same sensor that measures the ambient light. The pre-flash exposure information is evaluated and used to calculate both the flash-to-ambient light ratio, and the output of the flash unit prior to the main flash being fired. When used in conjunction with first curtain synchronization, the pre-flash is barely perceptible, but when used with second curtain sync there will, assuming the exposure is long enough, be an appreciable gap between them.

E-TTL II and i-TTL are the latest incarnations of Canon's and Nikon's flash metering systems. Though broadly similar to the E-TTL and D-TTL systems that preceded them, these systems offer enhancements to improve exposure accuracy. The first involves utilizing lens-to-subject distance information in the exposure calculation, to assist in determining the appropriate output for the flash. With E-TTL, the flash output was linked to the currently selected focus point, which makes sense, as it's likely that the point of focus is also the area you want to illuminate with the flash. However, this could cause problems if you recomposed a shot after gaining focus, so E-TTL II performs a comparison between the ambient and the pre-flash light levels of the scene to determine where the subject lies. This means that recomposing a shot won't fool the metering system. In addition, the E-TTL II metering system also ignores areas of high reflectance that could confuse earlier flash metering systems.

When you can use D-TTL		
Situation	D-TTL	D-TTL Return Distance
Indoor direct flash	Yes	Yes
Indoor bounce	Yes	No
Fill flash	Yes	Yes
Multiple units (wired/wireless)	Yes	No
Multiple units (flash-triggered)	No	No

Flash exposure compensation

One of the most useful settings on a digital SLR is to adjust the exposure compensation, telling the camera to record an image a stop (or a fraction of a stop) brighter or darker than it would do automatically. Digital TTL systems allow the same to be done via the flash unit's controls (for external units), which leaves the camera's exposure compensation control available to be adjusted separately. For some scenes the effect is simply cumulative: a +1 setting on the camera might be cancelled out by a -1 on the flash. However, when you're using fill-in flash, different algorithms will be used by the camera and you can adjust the camera exposure and flash exposure independently for greater creative control.

REFLECTIVITY

TTL metering systems are vulnerable to bright light coming from surfaces like this road sign, which has enhanced reflectivity. This will encourage the flash to cut out early (or fire less brightly). As a result, the rest of the subject might receive too little light.

COMPACT ADVANTAGE

Zoom compacts have always had the advantage that they could use any shutter speed with flash, without any problems with synchronization. In the days of film, a mechanical leaf shutter was used—an arrangement in the lens itself that combined the aperture and shutter. Nowadays, most compacts use an electronic shutter, where the length of exposure is controlled by the imaging chip. With both systems, any shutter speed can theoretically be used with flash.

Although few "mass market" compact provide the manual control to take advantage of this fact an increasing number of high-end models do, such as Canon's G9 and Nikon's Coolpix 5100. Indeed, these cameras also feature hotshoes that will accept the same dedicated flash units as a digital SLR using the same, advanced TTL control.

USING FOCUS INFORMATION

Modern flash metering systems use information from the camera's focusing system to find out how far away a subject is by reading the focus distance from the lens. Where the subject is in the frame can also be discovered by seeing which focus point is active. This information is balanced with the ambient light readings and pre-flash bursts to help the camera to understand the scene, and better judge the distance and importance of other elements in the frame. With this information it is easy for the metering systems to ignore bright highlights from reflections and the deep blacks of very distant backgrounds that might otherwise confuse a light measuring system. For these systems to be effective, the flash must be mounted in the camera's hotshoe, as it is essential the flash is the same distance from the subject as the lens.

Manual flash

Despite the point-and-shoot convenience of modern flash metering systems there will be times when the photographer needs full control. Alternatively, you may simply want to override the settings to get a slightly different result to the one the dedicated team of camera and flash unit have produced.

For many flash techniques it is best to switch the flash to manual, although not all flash units offer this facility. Set to manual, the output of the flash has a preset duration and intensity, so you can work the other camera settings around this, safe in the knowledge that the flash will deliver the same amount of light over a series of frames.

With studio flash units, manual control is the only option. You set how much power the capacitor is going to deliver, then alter the aperture, flash position, and flash diffusion to get the lighting effect you want.

Even with built-in flash units you retain some control, as you can set the power level manually. The full power setting delivers the flash's maximum guide number, and this is particularly useful when trying to light large scenes, or when you want to set a smaller aperture. However, you may well be able to reduce the flash output to half- or quarter-power by using flash exposure compensation.

Top-of-the-range flash units offer an array of lower power settings, down to perhaps 1/64 or 1/128 power. Such low outputs can be invaluable for getting the shortest flash duration possible, and for use in some forms of close-up photography. A good range of low power settings is also a mark of a good studio flash unit. Although its maximum power rating is also important, having a range of output levels gives you much more control over your depth of field and greater flexibility when it comes to positioning the lamp.

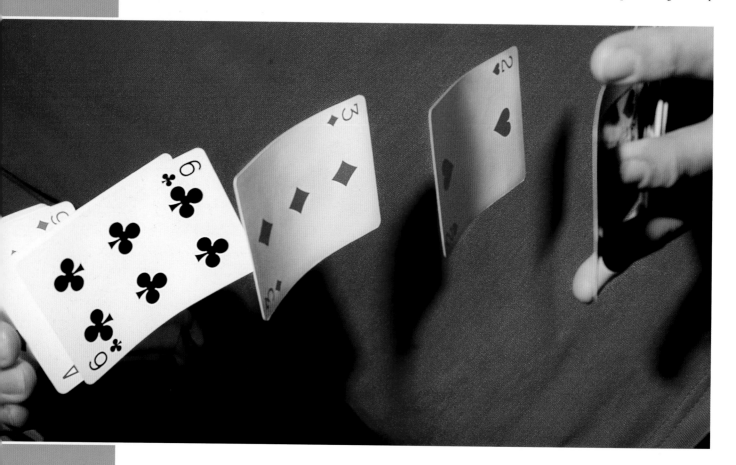

SLIDE RULE CALCULATIONS

Set to manual control, you can work out the necessary aperture setting through trial and error, but there are other approaches. If you know the guide number, you simply divide this by the distance to the subject to reach the correct aperture setting. Older electronic flash units (such as the one pictured here) have a look-up table so that once you have input the ISO setting, you can work out the aperture required for the power setting by estimating the focus distance, or reading it off the barrel of the lens once it has been focused on the subject.

PERFECT BALANCE

Taken with a macro lens and an off-camera flash, the difficulty with this shot was to get the exposure correct for the butterfly, flower, and blue sky. The right aperture, shutter speed, and manual flash power setting was found through trial and error, then used for a succession of shots of a Red Admiral feeding on a summer's afternoon.

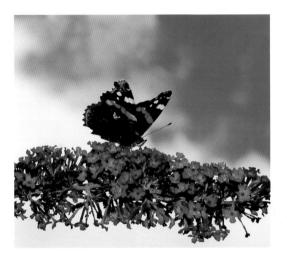

FLASH EXPOSURE COMPENSATION

Most digital cameras have automatic exposure control, and many have automatic exposure bracketing (AEB). This feature reels off a series of shots at different exposures, to help you make sure you get the correct exposure in tricky conditions.

AEB is invaluable in situations where you cannot stop and check the review screen and reshoot, but if you use exposure compensation or AEB with a flash exposure there may be no effect on the subject. This is because this form of exposure bracketing works by adjusting the aperture or shutter speed between each shot in the sequence. Depending on how the camera is set up, this may only affect the brightness of the background and not the flash-lit subject in the foreground.

For this reason, some digital cameras offer separate flash exposure compensation (FEC) controls. These affect only the power output of the flash, rather than the aperture and shutter speed being used by the camera. This allows you to isolate and manipulate the flash power to avoid or correct for an underexposed or overexposed subject.

CARD TRICK

To catch these playing cards in midair as they flew from one of the conjuror's hands to the other took lots of shots, as frequently only one card was caught during the exposure. To keep the variables to a minimum, and to avoid burnout on the white cards, the off-camera flash was manually set to half power.

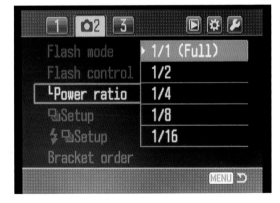

MANUAL POWER

When set to manual, this camera's flash menu offers five different power settings for the built-in flash, from full power to 1/16 power.

Two method of adjusting flash output: a separate dial (left) or an on-screen menu.

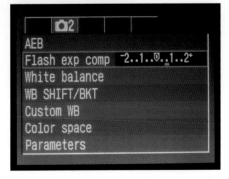

Handheld lightmeters

Given the sophistication of the metering systems in modern cameras it may seem strange that many professional photographers still use handheld lightmeters. The reason for this is because integral metering systems have two key disadvantages. The first is that they are built-in, so you need to move the camera or alter the shot setup if you want to take a reading from a specific part of the scene. The second, and more fundamental difficulty with built-in meters, is that they only measure reflected light. They tell you how much light is bouncing off the subject, but they don't tell you how much is falling on it in the first place and this difference is crucial, as some surfaces reflect light more efficiently than others.

Although most handheld lightmeters can take reflected light readings—by pointing the light reading sensor at the subject—they are most often used to take "incident" light readings. Using a diffusing, dome-shaped cover over the sensor, an incident light reading measures the amount of light falling on an area or subject. Unlike a reflected reading, the value measured would be the same whether the subject is jet black or brilliant white, which means it is less likely to be "tricked" into giving a reading that would under- or overexpose the subject.

Not all handheld lightmeters can measure flash, but those that do are particularly useful in a studio environment. The meter can be positioned in place of the subject (or immediately in front of it) with the diffuser pointing towards the camera. The meter will typically offer a range of readouts, but usually it is the aperture needed for the given lighting that will be displayed. The ISO setting and shutter speed will have previously been entered manually.

The strength of this system is that the reading can be taken each time the flash lights are repositioned, or the power settings altered, without having to move the camera.

An additional benefit of using a handheld meter is that you can take measurements from different parts of the scene, allowing you to see the brightness range provided by the current lighting setup.

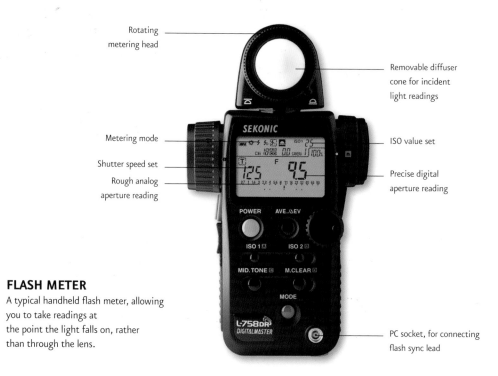

Rotating metering head

Removable diffuser cone for incident light readings

Metering mode

ISO value set

Shutter speed set

Rough analog aperture reading

Precise digital aperture reading

PC socket, for connecting flash sync lead

FLASH METER

A typical handheld flash meter, allowing you to take readings at the point the light falls on, rather than through the lens.

LOW KEY

A dark subject against a dark background is likely to cause problems for any built-in metering system, resulting in an overexposed image. These old cowboy boots are lit with a pair of softboxes in a studio, but the intention was to create a low-key image where dark tones dominate. The handheld meter suggested *f*16 as the "correct" aperture. However, exposure is a matter of taste and the slightly darker version shot at *f*22 is probably most peoples' preferred version.

*f*32

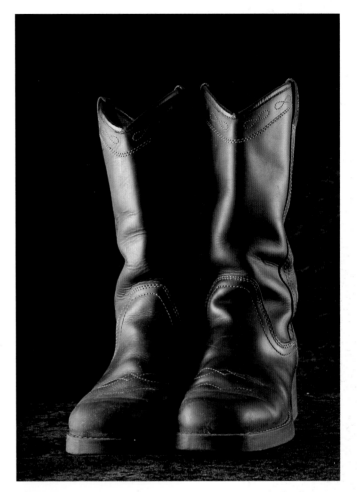

*f*16

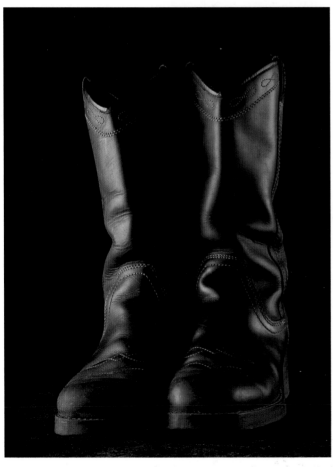

*f*22

*f*8

Built-in flash

Having first appeared on compact point-and-shoot cameras, built-in flash units have often been sneered at by serious photographers as the hallmark of snapshot photography. However, these small flash units can be extremely useful in a variety of photographic circumstances, and nowadays can be found on most digital SLRs. In fact, the only cameras you won't find them on are top-of-the-range professional SLRs and larger format camera models.

The SLR's integral flash typically has a guide number of between 33–43 feet (10–13 meters) when measured at an ISO 100 setting. This is not particularly powerful, but is well suited to head-and-shoulder portraits, or for general close-up photography.

However, the fixed position of the flash just above the lens axis makes its lighting very flat, and this frontal lighting provides no three-dimensional modeling. The positioning and small size also make it difficult to diffuse its output to give a softer effect, or to correct its inevitably uneven coverage. There is also the problem of certain lenses blocking the light path of the flash to parts of the picture, creating extreme local vignetting. Super-wide lenses and their hoods are a particular problem in this respect, but wide-apertured optics and super-telephotos may also cast a shadow across the picture area.

Despite these problems, a built-in flash can still be a lifesaver, allowing you to take pictures that would otherwise have been impossible or unsuccessful. Because you always have this flash with you, permanently attached and ready to spring into action, it doesn't matter if you haven't got a more powerful flash, making the inbuilt flash perfect for unexpected grab shots.

Built-in flash is particularly useful for fill-in flash and with slow sync techniques as the relatively poor quality of the lighting is not as noticeable.

**ROCK 'N' ROLL
PORTRAIT**
The output from a built-in flash is more than adequate for head-and-shoulders portraits, but can be used to good creative effect too. Here, a slow sync technique has been used, combining the onboard flash with a 1/30 sec shutter speed.

EVER READY

A built-in flash unit allows you to use flash even when you were not expecting to use it. Our cat had captured this mouse, and after rescuing it I had just enough time to shoot off a couple of frames. The dark corner of the yard where it was hiding made the flash a necessity.

SHUTTER SPEED ADVANTAGE

The low power from a built-in flash means it only works over short distances, but the range can be greater than you think. Using the onboard flash on an SLR for this farmyard shot (right) allowed the shutter speed to be raised from 1/30 sec to 1/125 sec, making it possible to take a shake-free shot with a 300 mm lens.

ICON CONVERTER

 Auto flash bracketing—but the same symbol is also used for auto exposure bracketing

 Flash compensation control

 Flash off—overrides the automatic flash

 Flash on, or flash ready

 Redeye reduction mode that uses preflash to minimize redeye

Hotshoe flash

Using a hotshoe-mounted flash does not necessarily provide better lighting than a built-in flash. The positioning of the flash tube may be slightly higher, but it still points along the same axis as the lens, creating flat, frontal lighting. However, being a separate unit there is scope for using the flash in other positions than on the hotshoe, providing a greater range of potential lighting angles.

A further advantage of a supplementary flash is that it offers more power. The higher guide number not only means the flash has a greater effective range, but it also gives more flexibility over the choice of aperture and, therefore, depth of field. You can also diffuse the flash output as, with the flash tube being a bit further from the lens, you can fit accessories in front of it to soften the light.

Many add-on flash units come with their own means to diffuse the output, either to change the coverage for wide angle lenses, or to soften the light. However, hotshoe flash units come in a wide range of shapes and sizes, and some are far more adaptable than others. The key features to look out for include:

Basic hotshoe flash

• Power
Hotshoe flashes typically have guide numbers of up to 184 feet (56 meters) at ISO 100. The more powerful a flash is the greater its effective range.

• Battery capacity
The more cells the flash takes, the heavier and larger it will be. But it will also recycle faster and keep running for longer. Some models have sockets for use with an external power supply, such as a Quantum battery pack.

• Dedication
Which camera-controlled flash features does the unit support? Does it provide a wireless off-camera TTL option, for instance, and which metering modes can it use?

• Manual
Not all hotshoe flash units provide a manual power setting, but this is a useful creative feature. The best units offer a number of manual settings, the lowest often being as significant as the highest.

• Tilt
A standard tilt facility allows you to tilt the head of the flash upwards so you can reflect the light from walls, ceilings, or other surfaces. This is commonly referred to as "bounced" flash and is used to soften the light from the flash. The head can typically be tilted through 90°, although the number of steps varies significantly. Some models can also be tilted down slightly—by around 5°—to improve coverage for subjects at very close distances.

• Rotate
An advanced bounce facility available with some flash units allows you to rotate the flash head as well as tilt it. This option is particularly useful for bouncing the light off walls to the side or even behind the photographer. The range of movement is usually between 180° and 270°.

• Zoom
Which focal lengths of lens can the flash adapt its coverage to, and is the diffuser moved manually or by motor? A detachable or pop-out diffuser may be provided for wide-angle coverage.

• Built-in slave
Some flash units have a built-in light detector that fires the flash when another nearby flash is fired, making it useful for off-camera setups using multiple flashes.

• Repeat flash
A "stroboscopic" action that pulses the light to give a time-lapse effect. This can show the movement of action subjects as multiple images on a single frame, or be used to allow high-speed synchronization.

• Catchlight reflector
Some tilting flashes offer a pull-out reflector to ensure a catchlight is created in your subject's eyes.

TRIGGER VOLTAGES
In theory, you can use practically any electronic flash unit on your camera's hotshoe. Although you may not get all the dedicated features, the standard central sync connector means that even ancient units will fit. However, using an old piece of equipment can possibly cause immediate or long-term damage to your camera because of the high voltages used by the flash during synchronization. Many manufacturers of digital cameras recommend a maximum trigger voltage of 5–12 volts (depending on the camera), but some older flash units may use a trigger in excess of 300 volts.

The maximum permissible trigger voltage may be different for the camera's hotshoe and its PC socket (if it has one), and an excellent website exists that logs the trigger voltages claimed by camera manufacturers, as well as measuring trigger voltages of flash units old and new (www.botzilla.com/photo/strobeVolts.html). To avoid difficulties, and to take advantage of low-cost second-hand flash units, adaptors for hotshoes and PC sockets are available that keep the trigger voltage within a safe range, such as those in the Wein Safe Sync range.

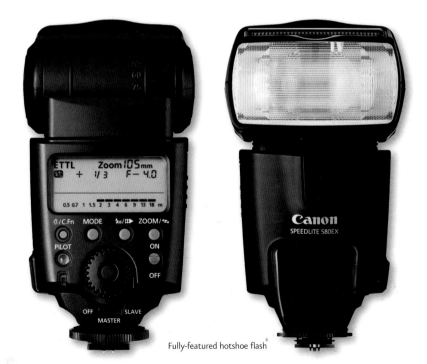

Fully-featured hotshoe flash

ICON CONVERTER

 Battery meter—gives a rough indication how close your flash or camera is to running out of power

 Second curtain synchronization

 High-speed synchronization mode

 Preflash metering in use

 Flash head tilted for bounce flash

Off-camera flash

Moving the flash away from the confines of the hotshoe means you can change, and often improve, the lighting characteristics of the unit. Mounting the flash on a bracket to the side of the camera makes a small, but noticeable difference to the way the shadows fall on the subject. Such an arrangement means that one side of a face is marginally better lit that the other, creating the modeling shadows that give a better three-dimensional representation. Ideally, the flash would be moved even further to the side for a more marked effect, but in order to keep the set-up portable a relatively small connecting bracket is typically used.

WIRELESS FLASH

An increasingly popular method of taking a flash off-camera uses wireless technology. Typically, a "controller" will be used on the hotshoe, as shown in the image below, which features Nikon's wireless macro flash system. The control module allows the camera to control a single flash, or multiple flash units, and as the technology has developed, this now extends to full TTL control, so that even using multiple flashes in a complex setup is almost a point and shoot excercise.

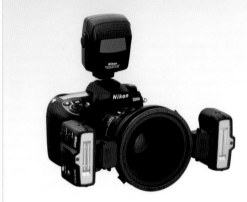

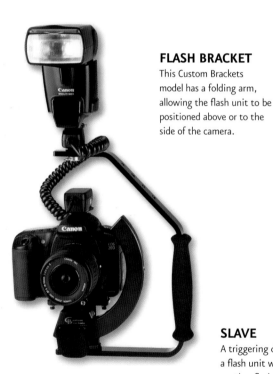

FLASH BRACKET
This Custom Brackets model has a folding arm, allowing the flash unit to be positioned above or to the side of the camera.

HOTSHOE ADAPTOR
Adds a PC sync socket to cameras that otherwise don't have one.

SLAVE
A triggering device that fires a flash unit when it detects another flash has been fired.

SYNC CORD
Connects hotshoe to off-camera flash.

INFRARED REMOTE
Fits to camera hotshoe and synchronizes firing of compatible studio flash units, eliminating the need for PC sync leads.

Built-in, on-camera flash

Off-camera flash, mounted on bracket

Of course, as soon as you forfeit the hotshoe link you have to find a way of making an electrical connection between the camera and flash (or use some other method to ensure you synchronize firing). A wire is the traditional method, and this often offers hotshoe-style connectors at either end. These may, or may not, retain some or all of the dedicated features that the flash unit and camera offer.

Other types of connector are available, and some digital SLRs and electronic flash units have a separate, dedicated, off-camera flash connector socket. More often, the camera and flash unit will use a basic PC socket. The initials stand for Prontor Compur—a legendary manufacturer that came up with this universal way of connecting a flash. The connector only offers basic firing (all dedicated features are lost), but is the most common way that off-camera flash units are linked up. Not all digital cameras have a PC socket, but hotshoe adapters can be bought.

Off-camera flash has been greatly simplified in recent years by wireless connection systems. Top-of-the-range electronic flash units and digital SLRs can synchronize firing without the need for cables. Preflash signals from the built-in flash unit are used as the form of communication. This wirefree system means that photographers can be more adventurous with the placement of their flash. The unit can be held at arm's length to provide a higher or more oblique flash angle than a bracket would allow, for instance, or the flash could be positioned on a shelf or table to alter the angle

even further. Such flash units are often provided with feet—sometimes even adjustable ones—so they can stand up without falling over. However, these wireless systems are not foolproof and, as with any slave setup, the ambient light level and sensor orientation can mean the flash doesn't fire at all.

FLASH POSITION

The difference between on-camera and off-camera flash can be subtle. The shadow on the wall gives away the change in the lighting angle, and putting the flash on a bracket also improves the modeling on the woman's face slightly.

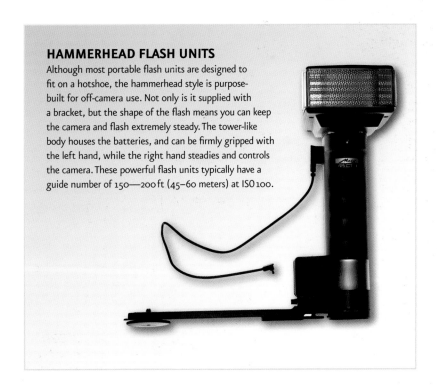

HAMMERHEAD FLASH UNITS

Although most portable flash units are designed to fit on a hotshoe, the hammerhead style is purpose-built for off-camera use. Not only is it supplied with a bracket, but the shape of the flash means you can keep the camera and flash extremely steady. The tower-like body houses the batteries, and can be firmly gripped with the left hand, while the right hand steadies and controls the camera. These powerful flash units typically have a guide number of 150—200 ft (45–60 meters) at ISO 100.

AC flash

AC flash is primarily intended for studios, although it may also be used on location for portraits and interiors. The most popular type is the monobloc (or monolight), which is an all-in-one unit that combines the flash tube, capacitor, and control panel in a single "head".

In comparison with some hotshoe flash units, studio flash units are huge, and that's before you add stands and accessories. But despite their bulk, the number of controls and features they actually offer can seem rather basic. Despite lacking the dedicated facilities of a portable flash, there are still important differences between models that must be considered when choosing a flash head:

• Maximum power
The power available from the capacitor is traditionally measured in Joules or watts per second. The more power available, the smaller the aperture you will be able to set, and the greater scope you have for diffusing the light. A monobloc light typically has a maximum power of between 200–1000 w/s.

• Variability of power
A big, powerful flash head may seem a good investment, but in a small studio it could be too powerful. In a large space you can reduce power by moving lights further away, but in a smaller one you may be forced to use the smallest apertures for every picture, surrendering depth of field control. The range of power outputs for a studio light is important as it gives you that control and, of course, allows you to make subtle changes to balance it with any secondary lights. A good studio light will offer a five-stop range, where the minimum setting is 1/32 of full power, and this will be controlled manually.

• Consistency of power
One of the features that distinguishes budget lights from quality ones is the "repeatability" of the flash output. With a good flash unit, the lighting intensity should remain the same for successive shots that are taken at the same power settings. If the output from the flash isn't consistent it makes studio work much harder as the exposure will effectively be changing between shots.

• Audible indicator
Even though it uses outlet power, a studio flash may still take several seconds to recharge between firing. An audible beep is a useful feature that will tell you when the flash is ready to take the next shot without you having to check it.

• Built-in slave
Most studio flashes have a built-in slave, but with some less expensive brands this is an accessory. Many systems offer optional infrared, or other wireless sync facilities.

POWER PACK SYSTEMS
An alternative to monobloc studio lights is to use a system in which the capacitor and main controls are separate from the flash heads. An advantage of this power pack approach is that only the lights have to be supported on stands while the heavy capacitor can stay on the ground.

Power packs normally have connections for between one and four lights, with the flash heads sharing the available power. The total power on offer typically lies between 1200 w/s (watts per second) and 4800 w/s.

Some versions are particularly suited to location use as they do not need to be permanently connected to the wall socket. Instead they use a large, rechargeable battery to power the flashes.

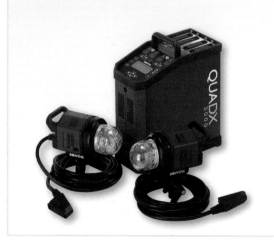

BASIC MONOBLOC STUDIO LIGHT

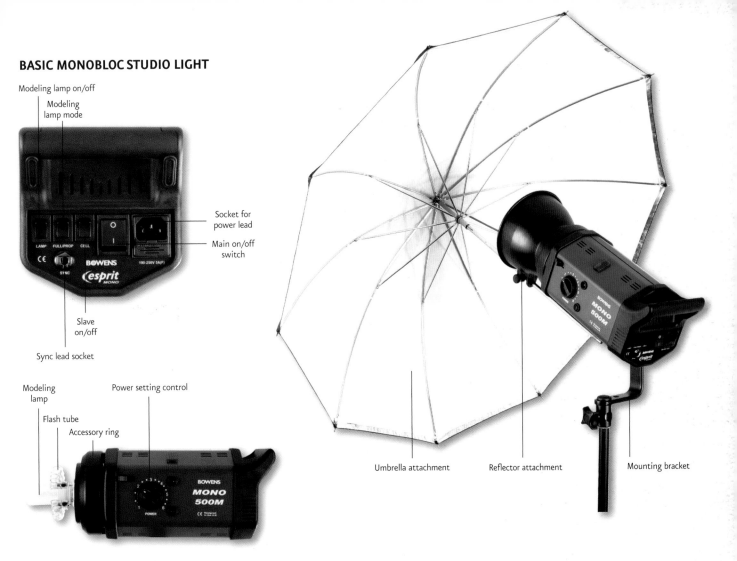

Modeling lamp on/off

Modeling lamp mode

Socket for power lead

Main on/off switch

Slave on/off

Sync lead socket

Modeling lamp

Power setting control

Flash tube

Accessory ring

Umbrella attachment

Reflector attachment

Mounting bracket

• Modeling lights

A modeling light provides a continuous light source that roughly equates to the flash's final visual effect, allowing you to adjust the light's position and diffusion. It also provides a light source to work by, and to preview the scene. It is useful if the modeling lights can be turned off, say, when a long exposure is needed to record ambient light from the subject itself.

Some modeling lights offer proportional output, so they vary in brightness depending on the flash's power setting, while others simply offer one brightness level. Typically, the modeling light is continuous, turning off only briefly as the flash is fired, but some lights offer an intermittent setting, where the modeling lamp only comes back on after the capacitor has recharged.

BUDGET SOLUTIONS

AC-powered flash does not have to be expensive. Flash units are available that fit into standard Edison screw (ES) light sockets in ceiling or table light lamp holders. These provide a high-output, daylight-balanced replacement for your usual tungsten bulbs. With clamp-on bulb holders and stands, these can be used as miniature alternatives to larger studio lights, although the range of accessories available is limited.

The power of these screw-in AC flash units can vary from a guide number of around 26 feet (8 meters) to around 90 feet (27 meters) at ISO 100, depending on the coverage you need from the light. They usually have a built-in slave, but may also have a PC sync socket for wired firing.

Studio systems

A studio flash unit is the heart of a whole system of accessories and add-ons, and this modular system is what makes studio flash so versatile.

There is a bewildering choice of bits and pieces to attach to the flash units, and that's not including other studio essentials such as a backdrop and the means to support it. The exact number of accessories available will depend on the make and system of lights that you are using. Many are practically universal, such as the stands, but others need to have been specifically designed for the flash head they are to be used on.

Studio flash accessories can be split into two broad categories: ones that get the light into the right position, and those that modify the coverage and quality of the light from the flash head.

STANDS

Stands vary according to their maximum and minimum usable heights, weight, and the number of telescopic sections they are made from. These are four models from the Bowens range.

BOOM SUSPENSION

A stand's bulk means it can be hard to get it close enough to the subject without it appearing in the shot. This is a particular problem when you want to light something from above. In a purpose-built studio the solution is to use a ceiling-mounted tracking system to support the lights. Alternatively, a stand fitted with a boom arm can be used, with the light fitted at one end, and a counterweight attached to the other to stop it falling over.

A lighting stand might seem a rather dull, utilitarian piece of equipment, but it performs the essential job of holding the flash unit in the right position. Lighting stands come in a large range of sizes and styles, and as with tripods, the minimum and maximum height of the stand can be crucial. As the flash head often needs to be higher than the subject—to simulate sunlight—you may well need to extend the stand well beyond 6 feet (2 m), but to light backgrounds, or small subjects, the stand may need to be positioned almost at ground level.

Unfortunately, a single stand cannot do everything, particularly if it is to be stable enough to support the flash safely, so a trade-off needs to be made between bulk and weight. The most stable stands are harder to carry around because by definition they are the heaviest and made of fewer sections. Lightweight stands collapse into a smaller space when not in use, but are generally less stable.

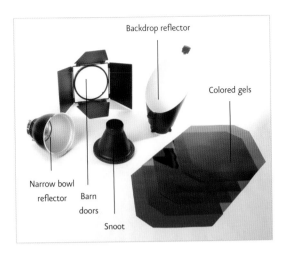

Backdrop reflector

Colored gels

Narrow bowl
reflector

Barn
doors

Snoot

MODIFYING THE LIGHT

These are a few of the many accessories used
to modify the light of a studio flash unit. The ones
that will prove most useful will depend on the sorts
of subjects you are photographing and the style you
wish to adopt.

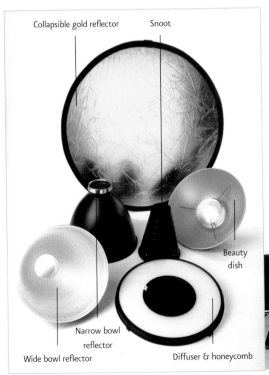

Collapsible gold reflector Snoot

Beauty
dish

Narrow bowl
reflector

Wide bowl reflector Diffuser & honeycomb

ALL-IN-ONE KIT

This all-in-one lighting kit consists of
three monobloc heads—plus most of
the key accessories you may ever need.

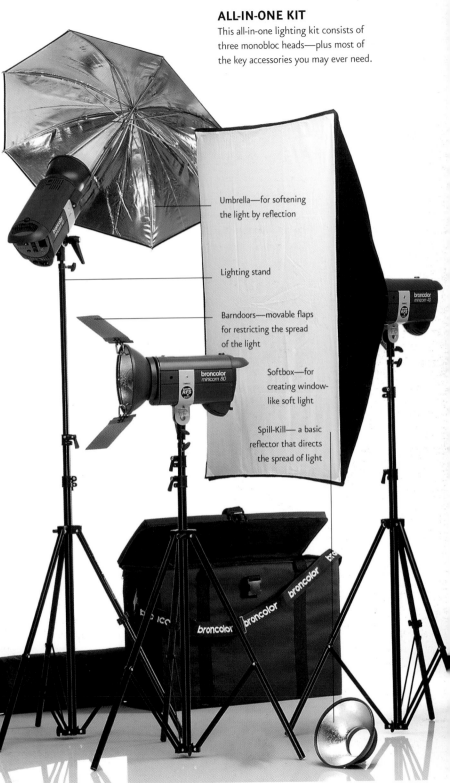

Umbrella—for softening
the light by reflection

Lighting stand

Barndoors—movable flaps
for restricting the spread
of the light

Softbox—for
creating window-
like soft light

Spill-Kill— a basic
reflector that directs
the spread of light

Batteries and recycling times

Just like your camera, portable flash units are reliant on batteries to function and charging up your unit's capacitor ready for action can use a lot of electrical juice.

A built-in flash unit uses the camera's own power supply, and this battery will usually take half the number of exposures if the flash is used. Such statistics aren't completely reliable, however, as the amount of energy a flash uses each time it fires will vary significantly and it is rarely necessary to shoot with full power. In automatic modes, the flash duration is kept as short as possible, saving the capacitor's unused power for the next shot.

However, although the number of shots you take is important, the amount of time that you have to wait between shots is just as significant. If the flash is shooting at full power, or the batteries are on their last legs, then a hotshoe unit can easily take 30 seconds or more for the flash-ready light to show that the capacitor is charged for another exposure.

This "recycling time" between shots, and the number of exposures you can take, varies not only according to the type of flash being used but also the particular power source. Most cameras give you little scope to change the type of power pack you use, so the only solution may be to make sure that you have one or more fully-charged or fresh spares with you.

Portable flash units are commonly powered by standard AA cells, offering you a wide choice as to the actual type of battery you use. The first choice is between single-use and rechargeable cells. Disposable batteries are excellent for emergencies, as they are so readily available, but for reasons of economy, rechargeable cells can be a prudent option, repaying the extra expenditure needed for the charging unit and batteries within a handful of use cycles. However, rechargeable AA cells will not offer as many exposures, nor as fast recycling times, as a fresh pair of alkaline or lithium disposables.

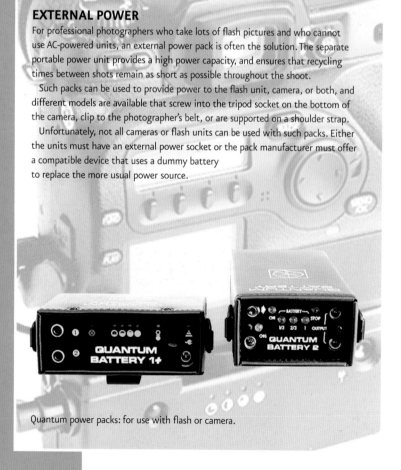

EXTERNAL POWER

For professional photographers who take lots of flash pictures and who cannot use AC-powered units, an external power pack is often the solution. The separate portable power unit provides a high power capacity, and ensures that recycling times between shots remain as short as possible throughout the shoot.

Such packs can be used to provide power to the flash unit, camera, or both, and different models are available that screw into the tripod socket on the bottom of the camera, clip to the photographer's belt, or are supported on a shoulder strap.

Unfortunately, not all cameras or flash units can be used with such packs. Either the units must have an external power socket or the pack manufacturer must offer a compatible device that uses a dummy battery to replace the more usual power source.

Quantum power packs: for use with flash or camera.

BOOSTER PACKS

Some digital SLRs have optional grips available to provide increased battery power, and these are particularly useful if you frequently use the built-in flash. This Nikon unit can take up to two rechargeable batteries, and when these fail, they can be replaced with disposable, or rechargeable cells.

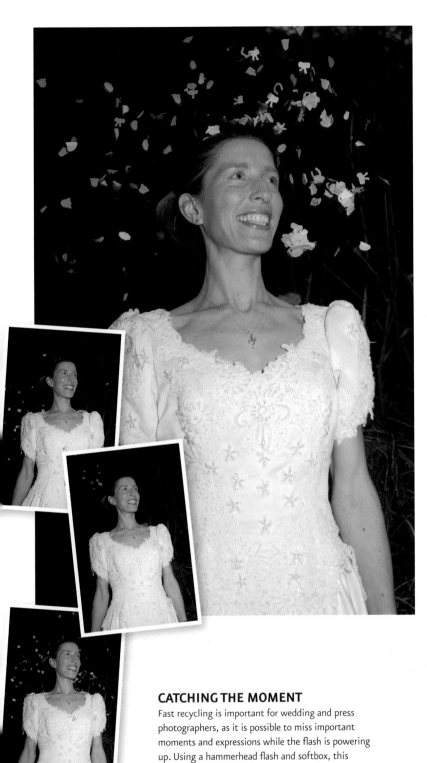

BATTERY TYPES

Alkaline
By far the most popular type of disposable battery. Some brands are specially designed for high-drain gadgets such as flash units, offering a longer life, but at a higher price.

Lead Acid
Ancient rechargeable technology, as used in your automobile. Occasionally used for separate high-capacity battery packs.

Lithium
High-power, but high-cost, disposable technology. An ideal fast-recycling solution for flash units that are compatible with this sort of battery.

Lithium Ion
Most commonly used rechargeable battery type found in digital cameras. It is lighter and more compact than other rechargeables, and can be recharged without being fully run down first. As with all rechargeable batteries, they do not last forever and will need replacing every few hundred cycles.

Lithium Polymer
High-tech successor to lithium ion, offering an even lighter rechargeable solution.

Nickel Cadmium
"NiCad" is an old-fashioned rechargeable technology. It should be completely run down before recharging to maximize its useful life.

Nickel Metal Hydride
Successor technology to nickel cadmium, this has no "memory effect" problem so can be recharged even only when partially run down. "NiMH" is a popular choice for AA-sized rechargeable batteries.

CATCHING THE MOMENT
Fast recycling is important for wedding and press photographers, as it is possible to miss important moments and expressions while the flash is powering up. Using a hammerhead flash and softbox, this sequence of confetti being thrown was taken using the "continuous" shooting setting.

Chapter two
ESSENTIALS OF LIGHT

2
**ESSENTIALS
OF LIGHT**

Recreating daylight

Lighting is all-important in photography, as without it you simply couldn't take pictures. The actual amount of light that you have is not the major consideration. It may be easier to take pictures in the middle of a bright, sunny day than it is to take them in the dim, first light of morning, but that does not necessarily make those pictures better. The slow shutter speeds necessary at dawn may require a tripod, or other solid support, but the conditions can often produce the most dramatic images.

It is the quality of light that is the important factor. Great lighting has the power to transform a mundane scene into a prize-winning one. Catching the perfect picture is not just a matter of being in the right place and using the right settings on the camera. It is also a matter of firing the shutter when the lighting is at its best.

Learning how to make the most of daylight is a major part of the photographer's craft. Although you have little or no control over the sun, the skill is to learn how the quality of the sunlight changes from minute to minute, from hour to hour, and from season to season. Clouds create ever-changing diffusers for the light, while the height of the sun has an effect on how the shadows fall over the subject.

The quality of light is equally important with flash photography. To get good pictures you must do more than simply throw light on a dark subject, and to get the position and characteristics of the flash right it is often a case of making the flash look as much like sunlight as possible. Sunlight, for instance, can light a subject from a wide variety of angles depending on the camera position and the time of day. Each of these makes subtle changes to the intensity and placement of the shadows in the scene. Learning to use these lighting angles creatively helps with flash photography, too.

It is also useful to acknowledge the differences between flash and sunlight. The shadows in a good sunlit photograph are rarely completely dark because of reflections from other objects. It is useful to re-create this fill-in effect when using flash. Similarly, the sun is almost always higher than the subject, so elevating the flash can help make pictures more realistic. Similarly, putting the light below the subject will make it look sinister and unnatural.

CLOUDS AND DIFFUSERS

Clouds can mean that outdoor lighting might change in seconds. In these three views of Maine's Cape Neddick lighthouse, you see how this effect changes the areas that are spotlit, and varies the amount of softening given to the sunlight. In flash photography, this effect is re-created using diffusers.

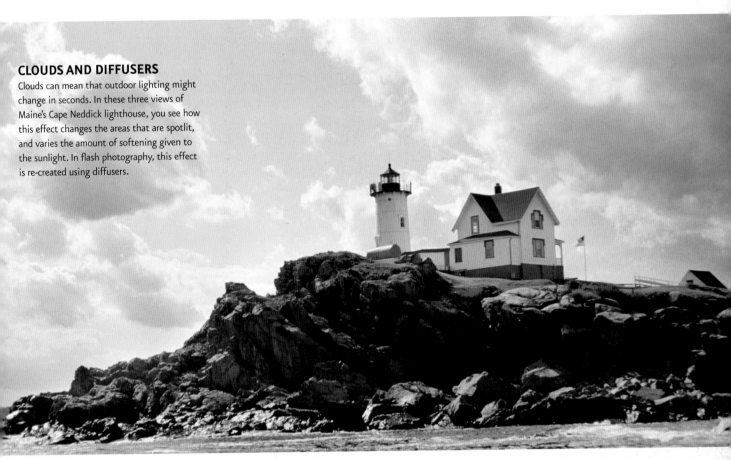

TIME OF DAY

Even without clouds, the height of the sun affects the intensity of the sunlight. These two shots of New England churches show some of the differences between shooting in the middle of the day and late afternoon. The first (above left) gives a high-contrast scene, with strong highlights and shadows, and intense colors.

In the second (below left), the color is more muted, but generally warmer, and there is far less difference in brightness between light and dark areas. With flash photography, contrast can be controlled using secondary flash units or reflectors for fill in.

Frontal lighting

The angle of the light in relationship to the camera is crucial to the way that the subject will appear in the picture. It is this angle that defines where shadows will fall, and dictates just how well color, shape, three-dimensional form, and texture will be recorded.

In reality, the position of the light can be anywhere in a 360° arc around the subject—and that's even before the height of the light source is taken into consideration. However, the position and angle of the light can be split into three basic sources—behind the camera, to the side of the subject, or behind the subject. Each of these has its own distinct characteristics.

Frontal lighting—where the sun is behind the camera—has always been a safe choice for the outdoor photographer. Because most of the shadows are thrown behind the subject, frontal light creates a relatively low-contrast scene that is easy for the digital camera' sensor to expose for without any problems. A lack of shadows also means that frontal lighting tends to give the most accurate color reproduction across the whole scene.

However, there are drawbacks with this form of lighting. With no shadows it is harder to get an idea of a subject's three-dimensional form. This can be a big disadvantage in a two-dimensional medium such as photography, as the viewer must rely on experience to know that a soccer ball, for example, is round rather than being a flat disc.

GLORIOUS COLOR
If you want to capture colors at their most saturated, then standing with the sun behind you is usually the best gambit, as in this shot of New Hampshire in fall.

FRONTAL FLASH

This simple still-life composition (also used on the following pages) shows the basic characteristics of the main lighting angles well. With a single flash directly to the side of the camera, the lighting is relatively even, with few shadows and highlights over the surface of the pumpkins. The orange color is even and strong, but subtle visual clues to three-dimensional form and texture remain.

Flash fitted with a mini softbox by the side of the camera, pointing directly at the subject.

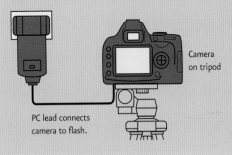

Camera on tripod

PC lead connects camera to flash.

For the same reasons, this form of lighting is also unlikely to give much information about surface texture, which often adds a sense of touch to the flat, representational photograph.

Most flash photographs, of course, use frontal lighting. The built-in flashes and hotshoe-mounted units are positioned to provide light from the camera, that travels in the same direction as the lens. This lighting position is convenient for photographer and manufacturer alike, and such a set-up can create good pictures. However, used on its own, this flat lighting is not ideal for most subjects.

SQUINTING FACES

Outdoors, direct frontal lighting is not ideal for portraits. The strong sunlight causes people to squint, and can create deep shadows in eye sockets and under noses. Frontal flash lighting avoids these particular problems due to its short duration and lower height.

Side- and back-lighting

Of all the three basic lighting angles, side-lighting is the most dramatic. By placing the light source somewhere to the side of the subject and camera, some parts of the scene are thrown into the spotlight, and others cast into shadow.

The dynamic mix of light and dark is perfect for revealing the three-dimensional form of a subject. The subtle gradation of tone can reveal the curves of a sphere, or of the human form. Surfaces facing in slightly different directions reflect varying amounts of the light back towards the camera, revealing corners, protuberances, and other details.

The contrast between unlit and lit surfaces can also be ideal for showing the texture of a surface. Raking light can reveal the dimples of an orange, or the hairs of a peach, and can even suggest the smoothness of a newborn baby's skin.

The difficulty with side-lighting is that the strong shadows it creates can reveal the form of one subject, but throw another into darkness. In complex scenes, with lots of subjects or image elements, the confusion of shadows can lead to a messy picture, so strong side-lighting is best used with simple compositions.

Of course, many lighting angles combine the characteristics of side-lighting and frontal lighting, reducing these difficulties. When external hotshoe or hammerhead type flash units are used off-camera they are most commonly positioned at an angle that provides a mixture of side and frontal lighting. Mounting a flash on a bracket, for example, pushes it out to the side and further away from the lens, so it takes on some of the characteristics of side lighting. However,

it is still basically a frontal light source, as the amount it can be moved to the side is limited by the length of the bracket.

Back-lighting, on the other hand, means that the subject is almost completely covered in shadow. With natural light and the right exposure this can mean creating a silhouette with little or no information about color. There is no contrast on the subject surface to give any information about texture or three-dimensional form.

For the flash photographer, re-creating this form of natural light is particularly difficult. It is almost impossible to get the flash behind the subject unless you have complete control over the scene and the situation. However, natural back-lighting is regularly mixed with side-lighting or frontal lighting provided by an accessory flash when photographing outdoors.

In the studio, back-lighting can be a useful tool, and the positioning of the lights behind the subject is straightforward. Back-lighting on its own is rarely used, unless a silhouette or a dramatic low-key effect is required, but in conjunction with lights that are positioned to the side or in front of the subject, a back-light can add an extra dimension to a subject. It can be useful for highlighting the edge of a subject that would otherwise remain in darkness, providing a rim-light effect to part of the image. This is a popular way of picking out the texture of a person's hair. A back-light is also very useful when photographing translucent subjects that may otherwise look opaque, or would lose their color under direct lighting.

REVEALING TEXTURE
A light directly to the left of this fern fossil helps to accentuate the delicate relief of the fronds that have remained buried in the rock for millions of years.

TRANSLUCENT COLOR
Back-light works well with transparent and translucent subjects. These slices of kiwi were placed on a sheet of Plexiglas, with the light positioned underneath.

FLARE

One of the main problems of back-lighting is flare, where strong, indirect light from outside the image area finds its way through the lens to create white streaks across the image.

Flare is a particular problem in the studio, as the restricted space and limited power of the lights means they need to be placed close to the area seen by the lens. Unlike outdoor work, a lens hood is not enough. To avoid flare from back-lights, and even side-lights, the lights themselves need to be shielded. Purpose-built accessories such as snoots and barndoors are regularly used, but "flags" made out of black card can also be taped or held in a suitable position to block stray and unwanted light reaching the camera.

SHAPES AGAINST THE SKY

London's backlit skyline, which shows little information about the color, form, or texture of the subject. However, thanks to the strong shapes, you can still identify the city.

SIDE-LIGHTING

The pumpkins have been lit by a single flash unit positioned to the left of the still-life setup. A mini softbox is used, but the pattern of light and dark over the scene is marked. Notice how intense the colors are in areas nestling between the shadows and the highlights.

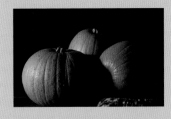

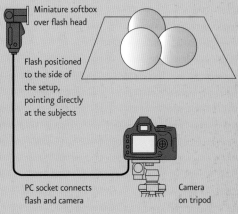

Miniature softbox over flash head

Flash positioned to the side of the setup, pointing directly at the subjects

PC socket connects flash and camera

Camera on tripod

HIGH BACK-LIGHT

A flash unit positioned high behind the pumpkins creates pools of light around the crowns of the pumpkins.

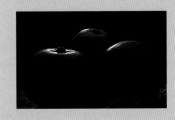

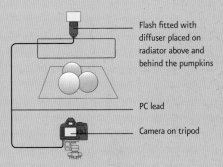

Flash fitted with diffuser placed on radiator above and behind the pumpkins

PC lead

Camera on tripod

LOW BACK-LIGHT

Alternative back-lit shot where the flash unit is hidden behind the pumpkins themselves.

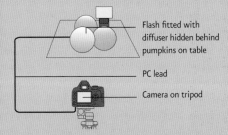

Flash fitted with diffuser hidden behind pumpkins on table

PC lead

Camera on tripod

Direct and indirect light

The quality of light is greatly affected by how scattered it has become on its path from the source to the subject. A "harsh" or "hard" light reaches the subject directly, without being scattered, creating harsh, distinct shadows.

Conversely, a "soft" or "diffuse" light source travels more indirectly, as the light is scattered on its path from source to subject. This type of lighting creates soft-edged shadows and lights the subject more evenly.

Light is softened through either diffusion or reflection. Sunlight, for example, can be diffused by clouds, and the thicker the cloud cover, the stronger the diffusion effect, and, consequently, the softer the lighting. On a very overcast day, the effect is so profound that almost no shadows or highlights are visible, resulting in

photographs that are often described as "flat" due to the low contrast between light and dark areas. Sunlight is also diffused by tiny particles in the atmosphere, and the extent of this effect will depend on how far you are from the equator, the time, the date, and the amount of dust and pollution in the air.

As well as being diffused by something physically positioned between the source and the subject, light can also be softened through reflection. Sunlight, for example, will be made less harsh as it bounces off walls, the ground, and even the sky itself. As the reflections are less than perfect, the light is again scattered and softened and the effect is so powerful that—even in direct sunlight—shadows are still lit to some extent by soft, reflected light.

Direct sunlight

By contrast, flash is a very harsh light source. There are no clouds to diffuse it, and as it is normally used at a close distance (at least compared to the sun), there is no body of atmosphere to soften the light. The combination of low power and a close proximity to the subject also mean that reflections from neighboring surfaces may also be minimal.

Portable and built-in flash units do have built-in reflectors and diffusers, but these do little more than even up the spread of light across the frame, so used pointing directly at the subject it is still a harsh light source. This hard lighting can be used to create great pictures, but some degree of softening is usually desirable in flash photography. The flash can be made softer in a wide variety of ways—through diffusion, reflection and power—as we shall see.

CLOUD COVER

Clouds are natural diffusers. The shot taken in direct light (below left) shows strong color and noticeable shadows in the bundles of lavender. When the sun is diffused by cloud, coloration is weaker and shadows are less pronounced (below).

Diffused sunlight

HARSH FLASH LIGHTING

Direct flash to the left of the scene produces harsh lighting with distinct shadows.

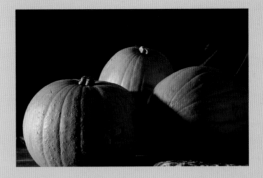

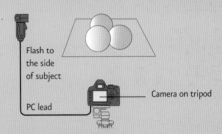

Flash to the side of subject

PC lead

Camera on tripod

SOFT FLASH LIGHTING

Indirect lighting from the same flash, in a similar position. However, this time the flash is angled up and away from the subject, and is diffused by bouncing the light off the walls and ceiling of the room.

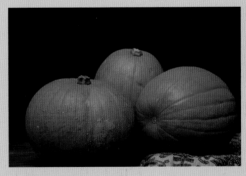

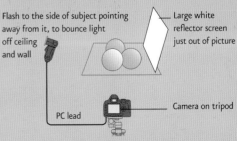

Flash to the side of subject pointing away from it, to bounce light off ceiling and wall

Large white reflector screen just out of picture

PC lead

Camera on tripod

Harsh or soft lighting?

There is a tendency among photographers to describe lighting as either hard or soft as if the distinction between the two were black and white. In reality, of course, how much a light source is diffused is a matter of degree. It is a stepless scale, and it is always possible to make a light source even more diffuse.

Always looking to use soft light can easily make you start to believe that harsh light is undesirable. Landscape photographers like the diffuse light of early morning, but that doesn't make all midday photographs failures. In fact, harsh light can suit some subjects.

The difficulty with flash, unlike sunlight, is that flash lighting is always harsh unless you do something about it. The lighting quality does not vary with the time of day or weather conditions, and you can become so used to using indirect, diffused flash that it's easy to forget that diffusing or bouncing isn't always necessary. Sometimes there are artistic reasons to point the light directly at the subject and exploit the harsh light.

Direct flash is ideal when you want strong, distinct shadows, for instance. A classic silhouette can be lit by an undiffused light source from behind, while harsh side-lighting can work well if you want to accentuate a subject's form, or want the shadows to be a prominent part of the picture in their own right.

High-contrast, harsh lighting is also well suited to those wanting the final result to be in black and white, or tinted monochrome as the absence of color means that the lack of subtle gradation between light and dark is less important.

Of course, undiffused frontal flash is what most people use for all their flash pictures and such flash may be the

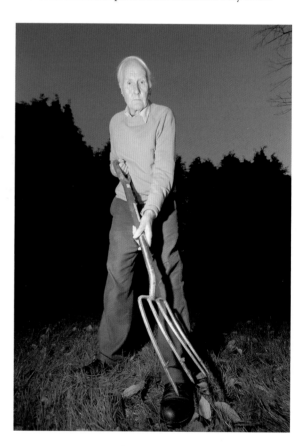

SHADOW AS SUBJECT
A wireless flash unit without a diffuser was used to provide hard side-lighting for this simple still-life set.

BUILDING CHARACTER
In this dramatic shot, the strong modeling effect of the light creates shadows that reveal every line on the subject's face. A wireless hotshoe flash was held to the left of the subject to accentuate the eerie feel of the low angle of view and wide angle lens.

only way of taking a useful photograph in low light. However, such direct frontal lighting is at its most effective when mixed with other light sources.

There are a wide range of ways in which to diffuse both portable and studio flash, and these are explored in detail elsewhere in this book. Whichever method is used the broad idea of softening the light is to reduce the strength of the shadows. An immediate advantage of doing this is that it reduces the contrast in the scene, making it much easier to expose the picture so that both highlights and shadows are kept within the working range of the camera's sensor. Aesthetically, this also means that unsightly, overbright areas in the image are reduced, and detail can be preserved in the darker areas of the frame. The more diffusion that is used, the lower the contrast in the scene.

The photographer will rarely want to remove all shadows though. Such flat lighting is suited to flat subjects, but for most subjects it is the contrast between light and shade that not only helps describe form and texture, but is also what makes the picture.

As a general rule, the more complex the scene, the softer the lighting needs to be. A group of people lit with a single direct light would mean that the shadows cast by one person would almost inevitably obscure the face of the next. For flattering portraits, even a single face is best lit with diffused light, otherwise facial features can create unattractive shadows.

COLLECTION OF COLLECTIBLES

With collections of objects, or groups of people, even lighting can help ensure everything, or everyone, can be seen equally clearly, as in this shot of collectible cast-iron toy vehicles.

Creative white balance

Despite the efficiency of automatic white balance systems, most digital cameras provide at least one way in which to override the color temperature setting. Cameras designed for creative photography will typically provide two or more systems to do so.

The most common manual white balance system provides a series of icons to represent a handful of useful color temperature presets. A sun symbol is for daylight on a sunny day, a cloud represents overcast conditions, and a glowing strip is provided for fluorescent lighting. These can be used in mixed lighting with flash to match a particular light source, but when using flash in daylight it is the flash or "sun" setting that will give a good color balance for both subject and background. Setting the balance to "tungsten" when shooting indoors with tungsten lighting and flash will produce a neutral background, but a blue subject.

More control and color temperature steps are provided by overrides that allow you to set a particular Kelvin setting. If you are not sure of the setting to use, you can simply take a test shot or two and look at the results carefully. With flash, a good use for this is to artificially warm up your shots. By using a Kelvin value that is higher than usual (misleading the camera into thinking the light is bluer than it actually is) you get an image with a golden glow, that is ideal for portrait subjects or warming up a landscape shot.

GOLDEN TOUCH
Backlit with a studio flash, the deep orange color of the whisky seems less intense than it does to the naked eye. In fact, the camera had set a white balance of 4500 K, trying to correct for the golden light. By setting the manual white balance setting to 9000 K, a more pleasingly colored shot was obtained.

Auto white balance

A third manual white balance system allows you to set the color temperature by taking a reading from a sheet of white (or gray) card. This can be a useful system where scientific accuracy is essential, and can also be used as a way of tweaking color balance. However, this manual white balance system has limited value in flash photography as it is only suitable for measuring ambient light.

MANUAL CHOICE
This digital SLR offers three manual white balance (WB) modes, in addition to a full automatic mode.

FILTERING THE FLASH

Although mixed lighting can create interesting colored backgrounds, for some types of photography it is preferable to correct the color temperature imbalance. The simplest way to do this is to cover the flash with a colored filter or gel. The color of the gel used is chosen so the output of the flash matches that of the ambient light source.

Gels are made in a wide range of shades, and are primarily sold to the film and video industry for correcting light sources. Because of this, they tend to be sold in rolls or larger, and more expensive, sheets than are needed for a portable flash. However, Midwest Photo Exchange (*www.mpex. com*) stocks suitably sized and priced packs of the two most usefully colored gels. These are CTO (color temperature orange) for converting flash to the same color as tungsten bulb lighting, and a Window Green gel for balancing flash with fluorescent strip lights. Cut-down sheets are also sometimes available through enterprising eBay traders. An alternative is to use the gold or green Omni-Bounce flash attachments produced by Sto-Fen (*www.stofen.com*) that do the same thing. An advantage of this more expensive solution is that the attachments provide built-in diffusion for direct or bounce flash. Unlike the gels, the right version needs to be bought for your particular flash unit.

Sto-Fen Omni-Bounce. Green and gold versions offer color correction for mixed lighting.

Manual white balance

Chapter three
FILL FLASH

Double exposure

Most people think of flash as a photographic technique that is used after dark, or in low light. Fill flash (or "fill-in flash") defies this preconception as the flash is used in daylight, or even strong sunlight. While this may seem like rather odd behavior, or even unnecessary, it is actually a very useful technique that even the most modest point-and-shoot photographer will benefit from.

Fill flash is also sometimes referred to as "synchro sun," and this alternate description gives us something of an insight into what the technique is about: fill flash uses two different light sources in tandem—daylight and the electronic flash unit.

There are a surprising number of different situations where using fill flash is advantageous or even essential. As we will explore in this chapter, it can be used to control image contrast, increasing or decreasing the brightness range offered by the ambient lighting. It can also be used as a way of manipulating the brightness of the background, or even as a technique to give you more control over depth of field. But it is the aesthetic considerations that make fill-in flash such a powerful technique. It is the stock in trade for the wedding photographer or the photojournalist, allowing them to capture bright and well-controlled images of unrepeatable events.

POCKET SUNSHINE
Fill flash is vital for the event photographer, allowing him or her to add sunlight on a dull day, or even to reposition the sunlight altogether if it is in the wrong place.

Fill flash can be used just as successfully for other photographic subjects, too. Some landscape photographers use it as a style statement, since it remains an unconventional method of adding foreground interest to the scenery. Social documentary photographers, such as Martin Parr, have used fill flash very effectively as a way of getting intense color from seemingly banal everyday scenes.

Combining flash and daylight together creates a more complex exposure. Technically, it is almost a double exposure, combining a flash image and an ambient one. The resulting possibilities allow you to manipulate the balance, and create different pictorial effects. The one limit to the creative use of fill-in flash is distance. Flash has a finite effective range, even in low light, but in bright daylight, and with small apertures, it is harder to make its impact visible. However, as the rest of the scene is already lit by daylight it is not so important that the flash only has a visible effect on part of the composition.

ABSTRACT EMPHASIS

The built-in flash found on most cameras is often more useful in daylight than late in the day. Here it successfully brightens up and saturates the color of the sign, drawing attention to the sign's amusingly graphic image of what happens to vehicles that don't heed its warning.

LIGHTING UP THE LAND

Flash is not as useful for landscapes as it is, say, for portraits. But fill flash can still be effective. Here it is used to reveal the color and detail of the rocks on the beach, without losing the gray Irish weather and landscape beyond.

3

FILL FLASH

Increasing contrast with fill flash

Dull weather often makes for dull photographs, simply because the lighting is so soft. An overcast day means that all the lighting is diffused, creating a scene that is evenly lit. The almost complete lack of shadows this causes means you have no information about depth. What's more, colors can become so muted that they seemingly merge to form a muddy, murky mess.

In such conditions, it is possible to make the best of it and try to find subjects that benefit from such flat lighting. Alternatively, if the subject is small enough and you can get sufficiently close, the camera's flash is capable of transforming the scene. In the case of many cameras you simply need to pop up the flash, or switch on the "manual flash" or "fill flash" mode, and then shoot.

Without flash

With flash

USING FILL FLASH

Combining a burst of flash with daylight, to lift detail from heavy shadow areas, is very easy with modern digital SLRs. Cameras with a built-in flash unit only need that unit to be activated and the camera will do the job for you. A hotshoe-mounted, dedicated flash will work in the same way, reading the daylight levels and putting out just enough flash light to brighten the darker areas of the shot.

To make fill-in flash less obvious the flash should be less bright than the daylight in the scene —perhaps 1/2EV or 1EV less. Using flash compensation features on the camera or flash will allow you to set the exact amount you want the flash to vary from the daylight, and if you're shooting using aperture priority mode, flash units simply set the flash to an aperture wider than the one you have set on the lens. If your lightmeter tells you that the daylight needs ƒ11 @ 1/125 sec, tell the flash you are using ƒ8 and it will put out less power. Fill flash should do just that—fill—rather than appear as the main light.

Without flash

What the flash does is add much-needed contrast to the scene. When the flash is camera-mounted it may do little to improve the modeling shadows on the subject itself, but simply lighting the foreground so that it is brighter than the background gives a lift to the image and offers a better impression of three-dimensionality.

The technique is particularly useful with portraits, and a godsend for events such as weddings, where waiting for better conditions, or using more sophisticated (but less portable) lighting equipment is simply not feasible.

The flash should not take over the image, but add the highlights that the dull ambient light cannot provide. As long as you are close enough to the subject—within a couple of paces, say—the flash will be enough to add a sparkle to a person's eyes and create a rough pool of light over his or her features.

Another benefit is that the flash adds a burst of strong frontal light that intensifies the colors of nearby subjects. This is particularly useful in portraits, where the color of the subject's clothing can be vital in helping to create a strong picture.

With flash

LEMURS

Taken on a dull day using ambient daylight alone, the shot (far left) of a ring-tailed lemur looks gray and lacks any punch. Using flash (left) adds much-needed contrast and color to the scene.

IN THE SPOTLIGHT

These two pictures were taken on a summer's day, and the sunlight was so intense that direct light would not work. The alternative was to shoot pictures in the shade of a garden wall. But although the contrast is contained, the bride's face is bathed in shadow. The answer was to add a touch of controlled sunshine, with the use of the SLR's pop-up flash.

Reducing contrast with fill flash

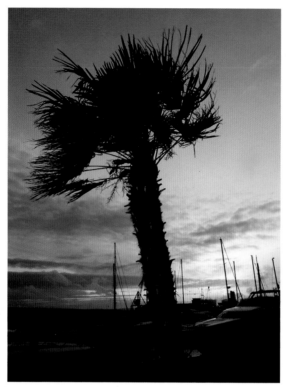

Without flash

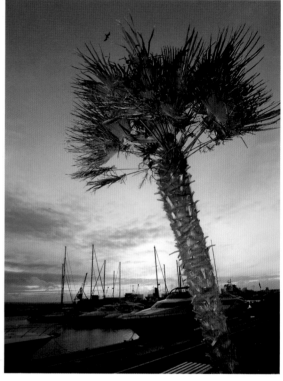

With flash

Fill flash works in two ways. It is not just useful for adding contrast in dull or shady conditions, but it can also perform the complete opposite. In strong sunlight, it can be an effective method for reducing image contrast to a more acceptable level.

The classic example of this technique is when shooting a backlit subject, such as a person standing with the sun behind them and their face in shadow. The camera's image sensor cannot correctly expose the bright background and the dark foreground simultaneously, which typically results in burnt-out highlights or blocked-in shadows.

Flash lighting, with its short, intense reach is the perfect solution to this exposure problem. It can illuminate the darker foreground, restoring a more balanced distribution of tones to the image. This in turn means that the camera can set the flash power to match the general exposure.

This approach is not just useful for avoiding unwanted silhouettes, it can also be useful with side-lit and front-lit

TREE
Fill flash completely transforms this shot of a tree. Lit by semi-diffused backlight alone, the tree is not just in shadow, the whole image lacks any impact. Fill flash combined with daylight creates a more striking shot of the tree.

subjects in bright, direct sunlight. Portraits are a particular problem in sunlight, as the undiffused lighting creates strong shadows around the eye sockets, under the nose, and under the chin. A burst of flash softens, or even eliminates such unwanted shadows, effectively ironing out the contrast problem.

SILHOUETTED STATUE

In this shot, the use of fill flash (top) is subtle. Without the flash the ancient stone statue in the foreground becomes almost completely black and merges into the trees. Using the built-in SLR flash, color and detail are revealed in the statue.

CATCHLIGHTS

A catchlight is a term used by artists to describe the bright highlight often seen in a subject's eyes. This white specular highlight is a reflection of the main light source in the picture. In portrait photography, catchlights are not just interesting details, but give a lift to the picture, as the sparkle they add makes the eyes come alive.

It is important to realize that when you look at a portrait (or a real person, for that matter) you look at their eyes first, and as you scan over the whole face or image you keep returning your gaze to the eyes. This means that how the eyes appear in an image is critical to a portrait's success.

In flash photography, the catchlight reflects the size and shape of the flash unit being used. A built-in flash will provide a small catchlight, but the shape and size of the catchlight can be controlled with studio lights by using add-on diffusers such as softboxes and umbrellas.

Fill flash catchlight
The white circular catchlight in the eye is created by the camera's built-in flash.

Studio catchlight
The twin rectangular catchlights in the eye are created by a pair of softboxes on studio flash units.

SHAPES

Different lighting equipment will produce different shaped catchlights.

Adjusting lighting ratio

Although fill flash is a simple technique to use, mastering it is rather more complicated. The difficulty comes with the exposure. Fill flash shots combine daylight and flash lighting together, and metering for both of these lightsources imultaneously is not straightforward.

Most cameras do a reasonable job of setting the right exposure for the flash, but this simply gives suitable settings for the area of the image lit by the flash, which is usually the main subject. What happens to the background, and other areas beyond the reach of the flash, is left to luck.

Flash exposures depend on three key components:
- **Shutter speed**
- **Aperture**
- **Flash duration** (the power setting used by the flash)

CHANGE IN BACKGROUND EMPHASIS

These two pictures of the same flowers were taken on the same day in identical lighting conditions, but the viewpoint and the effect of the flash on the overall exposure is very different. In the image on the right, the flash output is set to match the brightness of the sky in the background, creating a balanced exposure. In the left hand image, the use of flash has effectively darkened the background, giving extra emphasis to the in-focus flowers in the foreground.

1/40 sec

1/60 sec

1/100 sec

Normal ambient-light photographs use just the first two of these to set the exposure. Shutter speed and aperture are not only used to alter the overall exposure, but they are often adjusted in tandem as various combinations of settings will provide a similarly exposed image with different characteristics.

Low-light flash pictures, conversely, usually rely on just the last two of these factors to set the exposure, as flash is so brief that the camera shutter speed often has little effect on the picture.

With fill-in flash there are three different variables to contend with. Shutter speed now becomes crucial to the exposure, as this is going to help dictate the effect of the ambient light in the overall exposure. The brighter the ambient light, the more effect the shutter speed setting has on both foreground and background.

Balancing the aperture, shutter speed and flash power around the ambient exposure can create a range of effects. In simple terms, make an ambient reading and decide on your aperture according to the depth of field you want. Set your aperture and don't change it. Altering the shutter speed will determine whether the background appears light or dark, and changing the flash output impacts on the brightness of the subject. Overexpose the background by using a longer shutter speed though, and the subject will also be too bright, no matter what flash setting you use. The table below is based on a portrait scene with a general ambient exposure of ƒ11 at 1/30 sec, but with heavy shadows that need to be lightened with flash.

Fill flash can be used creatively by varying the ratio between the ambient and flash lighting. While the three exposure controls can be set so that foreground and background are perfectly balanced, making the background darker or lighter can often suit the composition. This can be used to intensify the color of a sky, for instance, or used as another tool with which to hide distracting elements in the distance.

SHUTTER SPEEDS AT SUNSET

The only setting that has changed in this sequence of shots is the shutter speed. This has no effect on the dark foreground, as you can see from the autumnal leaves that are just lit by the fill-in flash. However, the change in exposure duration has a noticeable effect on the sky. All three results are acceptable but the darkest version with the shortest shutter speed gives the most dramatic image, making the whole scene appear darker than it actually was.

Lighting ratios compared

Shutter speed	Aperture	Flash level	Result	Good/Bad
1/30 sec	ƒ11	ƒ8	Good general exposure with fill-flash lifting shadow details	good
1/30 sec	ƒ8	ƒ8	scene and subject overexposed	bad
1/60 sec	ƒ11	ƒ8	scene and subject too dark	bad
1/60 sec	ƒ11	ƒ11	scene darkened so well exposed subject stands out	good

Action subjects

There are two different approaches to photographing fast moving subjects such as sports. The first is to use a fast enough shutter speed to freeze the movement, and to rely on composition and context to give the impression of speed. The alternative is to use a significantly slower shutter speed than you would use to capture the action crisply, so as to provide an artistically blurred image suggesting movement.

The slow shutter speed approach is great for giving an impressionistic view of sport, and is a particularly useful technique to explore when light levels are low and faster shutter speeds are hard or impossible to achieve. However, the difficulty with this approach is that you can end up with too much detail being lost in the blur.

A compromise, in which some subject detail can be retained along with the blur, is to combine the slow shutter speed with flash. The longer than usual exposure provides the soft blur that suggests movement, and the brief burst of flash crisply freezes the subject at one point in the action. This double exposure effect creates an intriguing and unusual view of a sports scene, dancer, or playful child.

Unfortunately, the technique is not suitable for all action subjects, since you need to get close enough to the subject for the flash to be effective. This means being within a yard or two, so it is absolutely no use for shots of your favorite football player making a pass!

Events such as cycling and marathon running are ideal. Standing close to the edge of the track or road you can get close enough for the flash to do its work. As results can be slightly unpredictable (as with all blur shots), such events are useful as you can try out settings on a succession of competitors, or each time the person you're interested in passes by your part of the track.

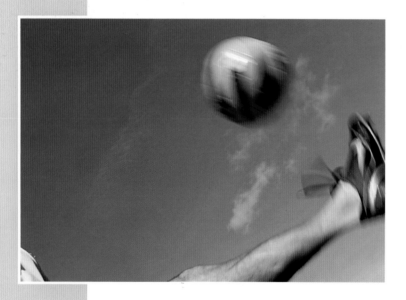

MAXIMUM SHUTTER SPEEDS FOR BLURRING ACTION

The actual shutter speed you need to blur action will depend not only on the speed of the subject, but also its distance from the camera and the lens setting you're using. This is because what counts is the speed at which the image moves across the viewfinder. The setting should be at least eight times (3 stops) longer than the minimum needed to catch it crisply, but even longer exposures can be attempted if light levels allow. It goes without saying that the shutter speed set should be equal to or slower than the maximum flash sync speed of the camera.

JUMP FOR JOY

How much of a blurred ghost image you get will largely depend on the speed of the subject and the shutter speed. Here the 1/60 sec shutter speed causes only slight blur, but the flash freezes the boy in midair.

Sports speed and distance comparisons						
Subject				Direction of movement		
	Speed	Distance	Focal length	Across frame	Toward camera	Diagonal
Cyclist	25 mph (40 km/h)	3 ft (1 m)	50 mm	1/500 sec	1/125 sec	1/250 sec
Sprinter	12 mph (20 km/h)	6 ft (2 m)	35 mm	1/125 sec	1/30 sec	1/60 sec
Jogger	6 mph (10 km/h)	6 ft (2 m)	70 mm	1/30 sec	1/8 sec	1/15 sec

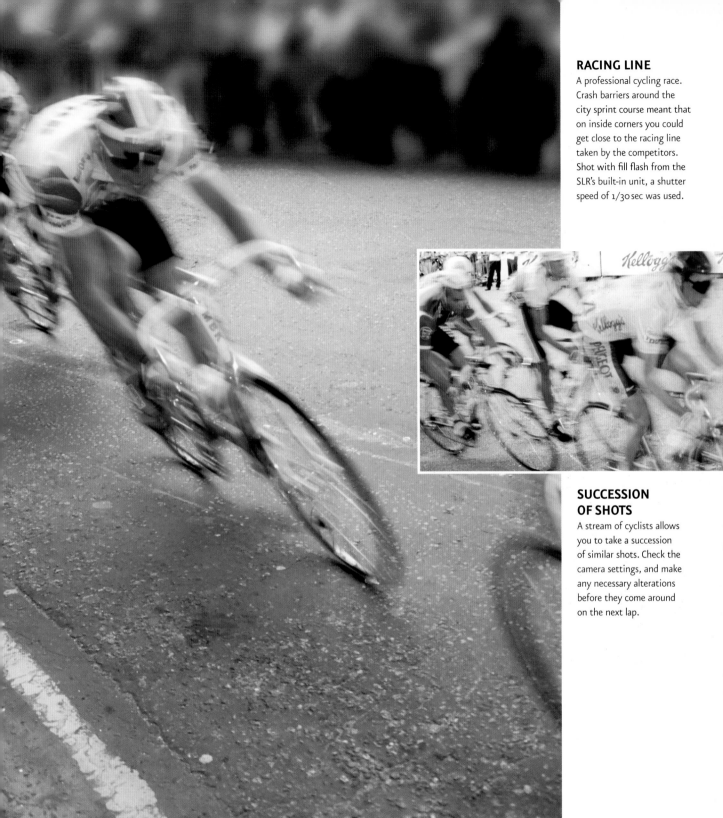

RACING LINE

A professional cycling race. Crash barriers around the city sprint course meant that on inside corners you could get close to the racing line taken by the competitors. Shot with fill flash from the SLR's built-in unit, a shutter speed of 1/30 sec was used.

SUCCESSION OF SHOTS

A stream of cyclists allows you to take a succession of similar shots. Check the camera settings, and make any necessary alterations before they come around on the next lap.

Low-light action

Fill flash is equally useful on bright, sunny days and in miserably dull conditions. However, its effect is often at its most potent at the end of the day. Whether there is a spectacular sunset or not, the darker sky frequently creates a more dramatic backdrop for a flash-lit subject.

For the action photographer in particular, such low-light conditions mean that it can be hard to get sharp pictures. Although there is little alternative to simply increasing the ISO with many sporting events, fill flash is an alternative if you can get close enough to the subject. An immediate advantage is that you can still use slower ISO settings, avoiding the noise and color artifacts associated with higher sensitivities. But the contrast and drama that low-light fill flash provides is almost ideally suited to action subjects.

Of course, it is possible to manipulate the exposure settings to make the background even darker than it is in reality, which has the effect of intensifying the color of the sky. Just as importantly it can mean that spectators, advertising billboards, and other clutter appears less prominent in the background.

This darkening effect can be particularly effective if you can get close enough to the subject to make use of a wide-angle focal length. Skateboarding and BMX bikers are frequently photographed in this way, as their stunts follow a predetermined path where an experienced (or brave) photographer can get within a couple of feet of the athlete to take some stunning pictures.

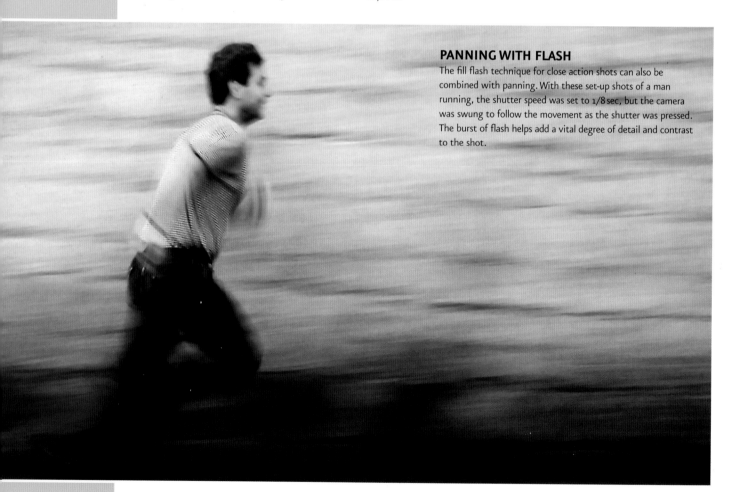

PANNING WITH FLASH
The fill flash technique for close action shots can also be combined with panning. With these set-up shots of a man running, the shutter speed was set to 1/8 sec, but the camera was swung to follow the movement as the shutter was pressed. The burst of flash helps add a vital degree of detail and contrast to the shot.

AFTERNOON AIR

A skate park at mid-afternoon in winter. The light is not bright enough for action pictures without flash, but it was possible to get close enough to the action to use flash and also use a wide-angle zoom setting. These shots were taken with 24–35 mm effective focal lengths, with the skater taking a line that only went slightly wide of the photographer's worm's-eye view. With shutter speeds of around 1/90 sec, and an aperture of around ƒ3.5, the sky is slightly darkened and the park surroundings are made to fade into the background.

BLURRED BOUNDARIES

The darker the conditions become, the more the subject is lit by the flash than by the sun. There comes a point when fill flash becomes low-light flash. Inevitably, the distinction between the two major flash techniques is blurred. However, flash is generally considered to be "fill" where daylight is still having a significant effect on the scene. In other words, the ambient light levels are such that you could have taken a sharp picture without the need for a flash or a tripod.

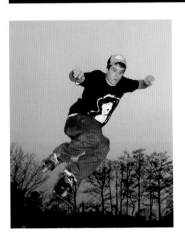
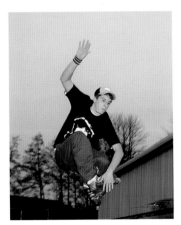
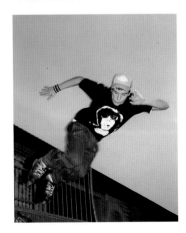

High-speed synchronization

Traditionally, the focal plane shutters used by SLR cameras have limited the range of shutter speeds that can be used with flash. Nowadays, however, nearly all digital SLRs can be used at shutter settings above the usual sync speed. However, in order to access this high-speed synchronization (HSS) facility, a dedicated flash unit needs to be used. Most manufacturers' best add-on flashes have this facility, as do some third-party alternatives.

Also known as "focal plane flash" or "pulse flash," HSS allows you to get around the usual difficulties of using flash with the fastest shutter speeds by altering the nature of the flash output itself. Rather than using a single burst of flash, the flash unit turns on and off at rapid speed. This pulsing effect typically fires the flash between 40,000 to 50,000 times a second (40–50 MHz). To the human eye the pulses are so fast that the output looks like normal flash.

However, by switching on and off in this way, the flash is able to prolong its duration. As the two shutter curtains open and close, the moving slit they form is constantly illuminated by the pulsating flash. The whole sensor therefore receives an equal amount of light from the flash, even if shutter speeds as high as 1/12,000 sec are used.

You might think that this high-speed sync facility is suited, as its name suggests, to action subjects, but in fact the facility is much more useful in allowing you to use the widest apertures that a lens has on offer. Flash units typically only give you limited aperture choice—making it hard to have as much control over depth of field as you would with ambient light. By allowing faster shutter speeds to be used, wider apertures can also be set.

As high-speed sync modes use a series of low-powered bursts to "build" brightness during the exposure, shorter shutter speeds require wider apertures to compensate for the reduced illumination level. As a result, using very short shutter speeds, such as 1/2000 sec, allows you to use extremely wide apertures, such as $f2.8$, to obtain a much shallower depth of field than would usually be possible with flash-lit scenes.

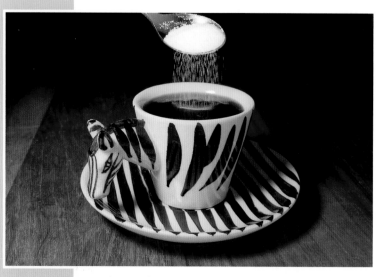

1/250 sec at $f11$

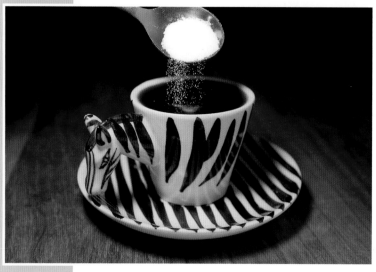

1/2000 sec at $f4$

EFFECTIVE SHUTTER SPEED

In low light, the duration of the flash usually becomes the effective shutter speed for the exposure. With high-speed sync, the flash duration and shutter speed become the same. These two shots show how HSS can be effectively used to get the extremely shallow depth of field much loved by food photographers. A diffused wireless flash was held above and to the left of the setup in both shots. Notice how the increase in shutter speed also affects how sharply the falling grains of sugar are recorded.

1/250 sec at ƒ9.5 Normal sync

1/4000 sec at ƒ2.4 High-speed sync

BACKGROUND BLUR

In this portrait, although the tree in the background is out of focus at ƒ9.5, it is still far from unrecognizable. Being able to use the standard 50 mm lens at its maximum ƒ2.4 aperture setting blurs the backdrop significantly better.

LOSS OF POWER

A side effect of high-speed synchronization is that it affects the guide number of the flash unit. The faster the shutter speed you use, the lower the effective power and the more limited the range of the unit becomes. As the drop-off in power is so marked at the fastest shutter speeds, HSS is often at its most useful with shutter speeds only marginally faster than the usual X-sync setting. The table below gives a guide to the power available from a typical flash unit using HSS:

Normal and high-speed sync guide numbers			
	Shutter speed	Guide number (feet at ISO 100)	Guide number (meters at ISO 100)
Normal x-sync flash	1/60 sec	120	36
	1/125	120	36
	1/200	120	36
HSS flash	1/250	30	18
	1/500	42	13
	1/1000	30	9
	1/2000	21	6.4
	1/4000	15	4.5
	1/8000	10.5	3.2

HOW HSS WORKS

Normal X-sync flash

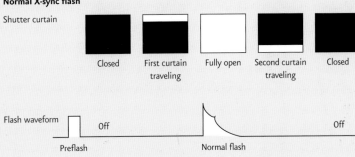

High-speed sync flash

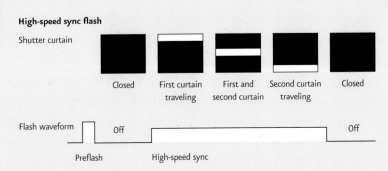

Chapter four
LOW-LIGHT FLASH

When not to use flash

UNDER THE SPOTLIGHT

A flash can be intrusive and in this case could ruin the enjoyment of other spectators. A high ISO setting allows a fast enough shutter speed to hand hold the camera, and the shot retains the atmosphere of the theatrical lighting.

LIGHT AS SUBJECT

The ambient light source itself is the subject of this image of a sea of tealights. Using flash would have ruined the atmosphere, and would have made the flickering flames less visible.

In daylight, flash isn't essential, but using it to fill-in will extend your shooting options. When the light gets low, however, there seems no alternative but to use flash. Many cameras are set up to automatically switch on the flash unit as soon as the ambient light drops below a certain level, but as useful as flash is indoors and after dark, it is still not always essential in these conditions. Indeed, in some situations a flash can make the image worse, not better.

It is important to realize that flash is not the only solution. It is perfectly possible with some subjects to use a longer shutter speed instead, while keeping the camera firmly supported using a tripod or other stable platform. When a slow shutter speed is not a sensible option, an alternative to flash is to increase the ISO sensitivity.

The decision to use one of these alternative approaches may be straightforward. The limited range of flash, for instance, means that a slow shutter speed is the only sensible solution for shooting cityscapes at night. Similarly, lowlight sports that are out of a flash unit's usable range, such as ice hockey, are best tackled using a high ISO setting, although noise from the camera's sensor can start to become a problem.

But even if the subject is within flash range, it may be best to leave the flash unit switched off. Flash, by its very nature, changes the lighting in the scene, and can end up dramatically altering the atmosphere created by the ambient light. Flash may increase the quantity of light hitting and reflecting from the subject, but it does not necessarily improve the quality of the lighting. When taking pictures of a theater performance, for example, straight flash will kill the drama created by the stage lighting. Similarly, a built-in flash can seemingly extinguish the candles on top of a birthday cake.

The dangers of camera shake and subject blur may mean that the choice between flash and slower shutter speeds may not be an easy one. You may have to make a decision between a sharp, flash-illuminated image, and a slightly soft version made with existing light. Similarly, when increasing ISO speed, there is increased noise in the captured image, which can show itself as red, green, and blue speckles in the photograph. However, if you want to use a higher shutter speed this can be the price you pay.

Ambient lighting only

With flash

If you are not sure whether or not to use flash, it is sensible to try both approaches. This basking chuckwalla was reasonably well lit by its vivarium lights—so a handheld, flash-free image at ISO 800 was worth trying. In this case, both versions are reasonably successful images.

If time and the situation allow, it is often worth trying to take images with and without the flash. This allows you to see which approach works best for a given subject, although it is worth noting that it is prudent to keep both versions, rather than deleting the seemingly weaker image after a cursory glance on your camera's LCD screen.

If the decision between ambient and flash lighting is difficult, it may well be one of the situations where an in-between approach is needed. As we shall see in this chapter, by using techniques such as bounce flash or slow-sync flash, it is possible to use flash without losing the atmosphere created by the existing lighting.

WHEN TO USE FLASH IN LOW LIGHT...

Reasons for...
- To increase working shutter speed
- To increase depth of field (by allowing a smaller aperture)
- To help freeze subject movement
- To reduce the time between successive shots (assuming the flash can charge fast enough)

Reasons against...
- When a tripod and slow shutter speed could be used
- Subject out of flash range
- Changes the atmosphere of the ambient lighting
- Draws subject's attention to camera's presence

The Inverse Square Law

The ways you can use flash are not only dictated by the fact that it has a limited range, but also the way that the illumination falls off with distance. This provides a challenge in any image where there are multiple subjects within the frame that are at different distances from the camera and flash. There is a constant danger that, even though you have got the flash to expose for the closest subject perfectly, anything farther away looks unnaturally dark, and anything closer to the camera looks washed out and over-exposed.

The difficulty is created by the property of all light known as the "Inverse Square Law." This states that the brightness of a light shining on a surface is not proportional to the distance between the light source and the subject, but by that distance multiplied by itself. Over a short distance, the light loses power extremely quickly, so a subject that is two yards away from the flash will receive only a quarter of the light compared to a subject that is one yard away. A face three yards away receives 1/9 of the light (3×3) and one five yards away 1/25 of the output.

You see evidence of the Inverse Square Law whenever you use flash in low light. With an indoor party portrait, for instance, backgrounds are dark, or even black, and you can't see things at the other side of the room.

This darkening effect can be an advantage, as it hides clutter in the background, but you have to set up your shot to take advantage of this. First, you need to ensure the background is far enough away so it is underexposed. You also need to ensure that the key subjects are the same distance from the flash so they are exposed equally. So, if you are shooting three people sitting on a couch, for example, take the shot from straight on, rather than from one side.

PROPERTIES OF LIGHT
This diagram shows the Inverse Square Law in action. The light from the flash is reduced in proportion to the distance from the subject multiplied by itself.

	1m	2m	3m
Relative strength of flash	1	1/4	1/9
Aperture needed	$f16$	$f8$	$f5$

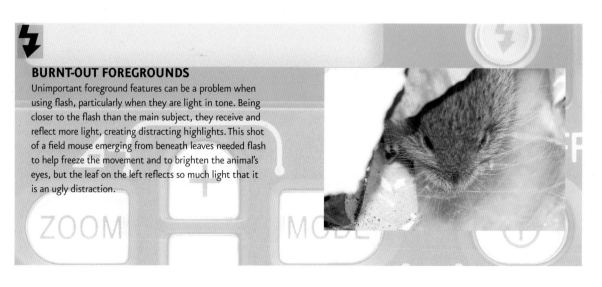

BURNT-OUT FOREGROUNDS
Unimportant foreground features can be a problem when using flash, particularly when they are light in tone. Being closer to the flash than the main subject, they receive and reflect more light, creating distracting highlights. This shot of a field mouse emerging from beneath leaves needed flash to help freeze the movement and to brighten the animal's eyes, but the leaf on the left reflects so much light that it is an ugly distraction.

INTO THE ABYSS
Shot in an indoor adventure playground, this portrait clearly shows the effect of the Inverse Square Law. Although the child is perfectly exposed, the ropes nearest the camera are slightly overexposed, wile the far end of the bridge is in total darkness.

Background choice

The key to successful low-light flash photography often lies in the background. With fill-in flash, the background is usually well lit by the ambient light, while in the studio the backdrop can be lit separately with another flash. However, with a single flash unit lighting the subject adequately will usually mean the background is underexposed.

A possible solution might appear to be to make sure that the subject is close to the background so they are both lit by a similar amount of flash. Unfortunately, taking this

DEPTH AND DARKNESS

These four shots show the effect of altering the distance between the subject and the background. Each shot was lit with a single hotshoe-mounted flash.

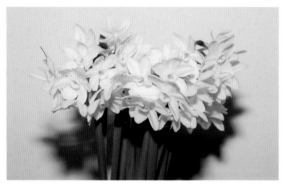

Distance to background: Eight inches
With the flowers so close to the background, the edges of the petals merge into their own dark shadows. However, the white wall does look white.

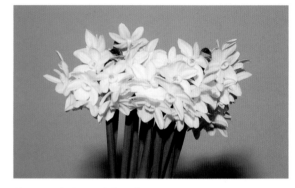

Distance to background: Three feet
Bringing the bowl of flowers away from the wall distances the shadows from the subject, but the wall becomes darker, and is discolored by the ambient room lighting.

Distance to background: Six feet
Bringing the flowers further away from the wall creates softer shadows, and a much darker background.

Distance to background: Distant horizon
Increasing the distance between the subject and background further may be difficult indoors. But going outdoors provides more scope. Here the flowers are photographed against a gray evening sky—which becomes a moody black in the flash exposure.

BLACK VELVET

The strength of shadows on the background largely depends on how dark the background is in the first place. Studio photographers are fond of using white backgrounds for taking pack shots, portraits, and other subjects. However, a white backdrop makes the shadows cast by flash highly visible. The shadows can be softened or eliminated in the studio by using two or more lights, each weakening the shadows of the other. With a single portable flash, however, a white background is not easy to use. Therefore, for simple still-life shots it can often pay to take the opposite approach and use a black background. Black creates an equally simple background for the composition, and shadows can be completely hidden, however close the subject.

 Not all black materials are as good as each other though, as some reflect more light than you might imagine. The best material to use is velvet because it absorbs light well, creating a rich, dark backdrop with no unexpected reflections.

SIMPLE STILL LIFE

Black velvet offers an ideal surface and backdrop on which to shoot small subjects with a portable flash unit. These colorful candies were shot on an old velvet shirt.

approach with a hotshoe or bracket-mounted flash inevitably means the subject casts a strong shadow over the background, and the closer the subject is to the backdrop, the darker and more hard-edged the shadow will become.

 Moving the subject further away from the backdrop will soften the shadows, but it also increases the distance between the shadows and the subject within the frame. These issues are most commonly encountered when photographing people indoors, such as at a family gathering, where you will find a person stood close to a wall will be bordered by a strong black shadow on one side. However, the wall will be well-exposed. If the person moves away from the wall, the shadow is thrown slightly further from the subject, and it will appear softer, although the wall will be darker.

 Which of these two approaches is best comes down to a compositional choice. Sometimes, background detail can be useful as it sets the scene, or provides valuable information about the event you are photographing. On many occasions though, the darkening of the backdrop helps to simplify the image, thereby encouraging you to find camera angles that maximize the distance between your subject and the background. The larger the room, the more scope you have for darkening the backdrop in this way.

Background and exposure

The relative darkness of the background in a picture does not just depend on its distance behind the subject; the exposure settings used also have an effect. For instance, if the background is beyond the range of the flash, you can make the aperture smaller and increase the flash power proportionately, which will make the background darker without affecting the illumination of the flash-lit subject. However, because the aperture affects depth of field, and the range of usable settings with flash is limited, it is the shutter speed that is the most effective control for altering the brightness of the background.

Unfortunately, there may be little or no scope for shortening the exposure in order to darken the background, as the shutter speed used may already be at, or near, the maximum available to ensure correct flash synchronization. However, with a compact camera and a lens shutter, or with a flash unit offering high-speed synchronization, a faster shutter speed is a useful way of darkening a distracting backdrop.

By contrast, there are no restrictions as to how long the exposure is when using flash (though you may need to set a "bulb" setting). This allows the photographer to lighten the background significantly, and lengthening the shutter speed to use slower shutter speeds than would normally be used with a handheld camera can be used as a powerful creative effect.

Background exposure is particularly important with interior photography. While one or more flash units can be set up to light the room adequately, it will be a matter of complete luck if the windows are adequately exposed. With bright outdoor weather, all you will see through the windows in your image is burnt-out highlights. If you are shooting late in the day, or on an overcast day, the windows will appear in your picture as if you had taken the shot in total darkness.

If you want to see what is beyond the glass, you need to create a balanced exposure that takes into account the

1/15 sec at f5.6

1/90 sec at f5.6

GARDEN VIEW

Shot with a pair of bounced flash units, one on a bracket and the other on a hotshoe. A change of shutter speed made the difference between whether you see the garden beyond the windows or not. A change in power setting was also required, to compensate for the increased ambient light levels in the room caused by the slower shutter speed.

ambient brightness outside the room. Shutter speed, aperture, and flash power will therefore need to be adjusted in unison.

A meter reading from the window area can be used to guide you towards the basic shutter speed and aperture to set for the exposure, shifting them in tandem until you can set a suitable power setting on the flash that works with the aperture. As the shutter speed will also affect the exposure in the room itself, fine tuning the settings is best done by trial and error, looking at the image and histogram on the camera's LCD screen after each test shot.

EXTREME MEASURES

A tripod and long exposure were needed in order to be able to see through the bathroom window in this bounce flash shot taken on a gray winter afternoon.

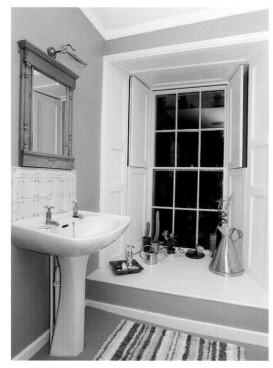

1/125 sec at f6.7

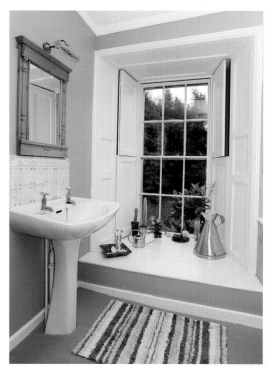

1/6 sec at f5.6

TRICK OR TREAT?

Dark, featureless backgrounds created by flash can often help a composition. Here the jet-black backdrop suits the Halloween portrait. Taken with the on-camera hotshoe flash, "Dracula" was shot outdoors to ensure the background would be dark, whatever the exposure settings used.

Diffusing portable flash

Flash creates a hard, direct light source. The light from portable and built-in flash units is particularly harsh, because the flash tubes are so small. The compact light source creates dark shadows and high-contrast illumination that works well enough with some subjects, but is generally unflattering in most situations.

Therefore, photographers frequently try to soften the light from a flash in order to improve its quality. The easiest way to do this with a portable flash unit is to diffuse the output by putting a translucent material over the flash. Doing this will scatter the light, making it considerably less harsh and more indirect.

All hotshoe and built-in flashes have a diffuser panel built in to them, but this does not miraculously convert hard light into perfect soft lighting. It is primarily there to protect the flash tube, although it does make the light slightly softer and more even. Adding more diffusing material in front of the flash, similarly, cannot produce miracles, but it will make the output a touch softer. However, just because the effect is slight does not mean the modification is not worth making.

Using an additional diffuser not only scatters the light, it also broadens the coverage slightly. A diffuser will also reduce the amount of vignetting, by reducing the intensity of the central hotspot of the flash. The net effect is that using a diffuser helps reduce the contrast by a small, but

HOW MUCH DIFFUSION?

There is no need to buy a purpose-made diffuser. It is simple enough to make your own using practically any piece of translucent material you can find that will fit over the front of your flash. White material is best, otherwise the color temperature of the flash is altered.

A piece of fabric will do, but tracing paper, foam sheeting, bubble wrap, opalescent plastic, or tissue paper can also be used. These can be held in position in front of the flash, using a rubber band or masking tape. Experiment with combining layers of different materials to create a more pronounced softening effect.

NO EXTRA DIFFUSION
Flash produces hard lighting with distinct shadows.

WITH DIFFUSER
The light is scattered by the translucent material.

MORE DIFFUSION
The more opaque the diffuser, the more diffused the light becomes, but power is reduced.

STO-FEN OMNI-BOUNCE
Although a universal version is available, Sto-Fen diffusers are produced in different sizes to fit snugly onto many popular flash units.

HOUSEHOLD MATERIALS
This is a selection of materials found quickly around the home that could be pressed into service as flash unit diffusers: cotton handkerchief, tracing paper, foam wrap, bubble wrap, and a PecPad cleaning tissue.

significant amount, which in turn helps reduce the amount of clipping in both highlights and shadows in digital photography. For this reason, it makes sense to use some sort of extra diffusion whenever using direct flash, even though this will cause a slight loss of power.

Many flash units are provided with add-on diffusers that are primarily designed for use with wide-angle lenses, but for general use they are still better than nothing. A popular purpose-built diffuser for hotshoe flashes is the Sto-Fen Omni-Bounce. This is made of white opalescent plastic and clips tightly around the flash head. As its name suggests, it is best used with the flash slightly tilted, but it will still provide good diffusion when it is used straight on if you find yourself in a situation where bouncing the flash is not possible or appropriate.

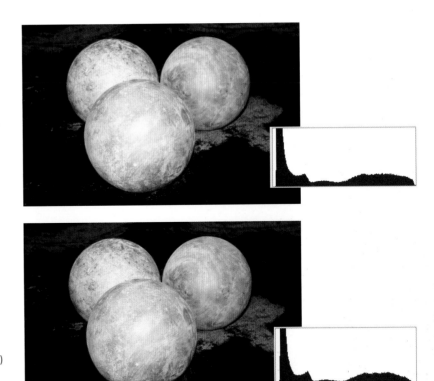

CONTRAST REDUCTION

Both of these pictures were taken with a hotshoe-mounted flash pointing directly at the subject. Adding a diffuser (bottom) makes a marginal difference, reducing the central highlight area slightly. But the effect is also noticeable in the histogram, where the diffuser squeezes both ends of the graph inwards.

FACING THE FIRE

Using flash to shoot a fire-breather might seem unnecessary, but the intense burst of light from the flame makes the camera set a shorter exposure, which would leave the girl's body underexposed. A burst of flash balances the light levels within the scene. A hotshoe-mounted flash with a Sto-Fen diffuser was used, with an exposure of 1/200 sec at f9.5, at ISO 100.

Portable softboxes

A softbox is a classic studio accessory for diffusing flash lighting, but although these bulky bolt-ons are not suitable for portable flash units, a number of manufacturers make smaller versions that will fit in front of a hotshoe or bracket-mounted flash unit.

A softbox softens the light by a greater amount than a simple diffuser attachment, by effectively increasing the size of the flash head. The diffusing panel used is significantly larger than the flash unit's own diffuser, and is held in position some way in front of the flash using a frame attached to the flash head (usually with Velcro fasteners). To prevent any light escaping through the gap, the sides of this tent-like construction are enclosed with material that is a reflective silver (or white) on the inside, and black on the outside. The reflective interior bounces the light through the front panel.

Softboxes come in a variety of sizes, and the larger the front panel, the more pronounced the softening effect will be. However, these devices make the flash unit bulkier and the camera setup more cumbersome, so the largest sizes are unsuitable for many subjects.

A portable softbox not only broadens the coverage of a flash and softens the light, but it can also provide larger, more attractively shaped catchlights in a model's eyes.

LASTOLITE MICRO APOLLO

These collapsible softboxes are available in several different sizes that will fit most hotshoe or hammerhead flash units.

LUMIQUEST BIG BOUNCE

A variation of the softbox concept that uses an internal reflector panel as well as a large diffuser panel to soften the light. Unlike a conventional softbox, it is only suitable on flash units with a tiltable head.

With softbox

Without softbox

SPREADING THE LIGHT

In this comparison (left), using the softbox has a marked improvement on the flash unit's coverage when using a wide-angle lens with an effective focal length of 19mm.

OUT OF THE SHADOWS

In this portrait shot (below), the model was photographed with a bracket-mounted hammerhead flash. Adding a softbox makes a significant difference to the quality of light and the shadows, particularly on the wall.

Without a softbox there is notable darkening towards the sides of the image

With a softbox attached the illumination is more even across the frame

4

Bouncing flash off walls

Bouncing the light from a flash unit creates a pronounced softening effect and delivers light that is far more diffuse than using a softbox or other diffuser. By tilting or rotating the flash head, the light from the unit is aimed at a nearby surface rather than the subject itself. As it reflects off this surface the light is scattered over a wide area, softening it and greatly increasing the coverage.

Bounce flash often produces a subtlety of illumination that direct flash cannot match. Furthermore, the lighting can be so even and shadow free that it is much harder to see that flash is actually being used. By creating an indirect light path, the photographer also neatly avoids the frontal lighting that flash usually provides. Bouncing the light off a ceiling creates a higher perceived light source, which looks more natural as it creates the same shadows as you would expect from normal room lighting or from a skylight. Alternatively, bouncing the flash off a wall can provide a degree of side-lighting that can make it look like the room is being lit by a large window.

However, there are difficulties with using natural surfaces to bounce the light off. A suitable surface can be the first challenge as the color of the paintwork is crucial. A white surface is ideal, as it will reflect the light well and avoid creating ugly color casts. Conversely, a pink wall would reflect pinkish light that may be difficult for the camera's white balance to correct for.

The distance of the surface you want to bounce the light off is also important. Even in a small room, bouncing the flash off a wall can easily double the distance between the flash and subject, which will reduce the maximum power by two stops. If you then take into account light lost during reflection you can see that with the greater flash-to-subject distances created by high ceilings and distant walls, even the most powerful flash unit becomes less effective.

FLEXIBLE FRIEND
The range over which the flash head can be tilted and rotated varies from model to model. The more flexibility, the greater your bounce options.

NATURAL LOOK
Bounced flash gives an even, diffused light that masks the fact flash is being used. This close-up looks as if ambient room lighting was used. In fact the main flash was bounced off a nearby wall.

ADDING CATCHLIGHTS

One disadvantage of bounced flash is that it does not provide the catchlights that direct lighting provides in portrait photographs. Some bounce flash units have a small reflector to add these back in, bouncing light from the tilted flash unit directly at the subject. An alternative, is to use a bounce flash off-camera, then use the camera's built-in flash on a low power setting to add the all-important highlights to the model's eyes.

WORKING PORTRAIT

Bounce flash is great for wide-angle portraits, for example showing a person's home or place of work as well as their appearance. Bounce flash creates even lighting over a wide area, and in this shot of an upholsterer in her workshop, the flash was bounced off the sloping roof to the left of the camera.

BOUNCE AND THE INVERSE SQUARE LAW

You have to remember that when you bounce flash from a wall or ceiling you are increasing the distance the light has to travel to reach the subject. The distance to measure is not from the camera to the subject, but from the flash to the ceiling/wall, then to the subject. This extra distance will reduce the power of the light when it reaches its target and the Inverse Square Law applies here just as it would for direct flash. However, with bounced flash you can expect the surface you use to soak up additional power, as most walls are not 100% reflective.

GETTING THE ANGLE RIGHT

A tilting, rotating flash head allows a wide degree of flexibility as to where you can bounce the flash from and still keep the flash on the hotshoe.

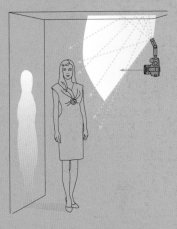

A wireless or cable-connected flash provides still more angles to choose from, even if the head is fixed.

However, you still have to decide where to point the flash to get the desired effect. Bouncing the flash off the ceiling is relatively straightforward. Aim for a point that is slightly nearer the camera than the target, so as to get the maximum amount of spread over the subject.

Bouncing off a wall is made more difficult because there is a danger that areas of the wall that appear in shot may be overexposed by the flash light. Bear this in mind when composing the shot, then take a test shot so you can check the histogram and highlight-clipping indicator to ensure areas of the wall are not burnt out.

Bounce without walls

Although bouncing the flash is a convenient way of creating diffuse lighting with the minimum of equipment, it is rather more difficult to use with some subjects than others. Even if there are walls or ceilings to provide the necessary reflective surface, they may be of the wrong color or be too far away to be of any practical use.

Fortunately, there are a wide variety of add-on accessories that provide a portable surface off which to bounce the light. These modifiers typically strap to the flash head, or are attached with Velcro strips. With the flash head angled straight upwards, the modifiers have a large white panel that tilts forwards 45° so the light is scattered and reflected back towards the subject as the flash is fired.

These modifiers provide a more direct path to the subject than most walls and ceilings, which means there is less light loss, but the resulting illumination is not quite as soft and shadowless. The bigger the panel provided, the better the diffusion, but the flip-side is that larger softboxes can be harder to handle. Nevertheless, given the range of sizes of these attachments, bounced light can be used in practically any situation where flash is needed, even outside.

BOUNCED AND DIFFUSED
The reflective surfaces of jewelry make the use of direct flash inadvisable. For this shot, the off-camera flash was not only bounced off a reflector panel, but the light was further diffused by covering the flash with a white cotton cloth.

Some of these accessories are sold with different colored panels, allowing you to modify the reflected light. A gold insert, for instance, will warm up the flash lighting to give a golden glow to the subject, while a silver reflector provides a more efficient surface for the light to bounce off to give more sparkle and contrast to the scene.

PLAYING SAD
With direct flash, the dog's blanket and paws would be burnt out by the flash. Bouncing the flash off a clip-on reflector provides much more even lighting, creating a more successful pet portrait.

Bounce flash

Direct flash

MUSEUM PIECE

This ancient Egyptian statue was shot using a single wireless flash bounced into a clip-on reflector. The flash was held to the right and above the camera to provide some side-lighting.

LUMIQUEST POCKET BOUNCER

This attachment folds flat when not in use, and its small size and light weight mean it is easy to carry around in a gadget bag. The pocket bouncer attaches to adhesive Velcro strips on the flash head itself. The amount of light lost is just over one stop, far less than when bouncing light using a typical wall or ceiling.

Redeye: Causes and solutions

For the majority of flash users, redeye is an all too common problem. Although it affects some cameras and some flash set-ups more than others, it is still something that every photographer will encounter.

The red eyes in low-light portraits are created by the flash reflecting off the retina and back-lighting the blood vessels in the eyeball. This causes the pupils (the eyes' own adjustable apertures) to appear red rather than the more usual black, and the effect is more noticeable in dim light, when people's pupils are fully dilated. However, it occurs in some pictures and not in others because of the distance between the flash and the lens, and the distance between the lens and the eyes of the subject. The critical factor is the angle between the flash, lens, and eye, and the narrower this angle, the greater the chance of redeye appearing.

Redeye has become a more significant problem in recent years for two reasons. The primary cause in compacts is due to their size. As the cameras have become smaller, this has decreased the distance between the built-in flash and the lens. Even if you're using an external flash mounted to

DISTANT FACES

Group shots are particularly prone to redeye as you tend to stand so much farther away from the subjects. In this night-time shot of Italian pageantry, not only does the main female subject have redeye, but so do many of the faces of the crowd in the background.

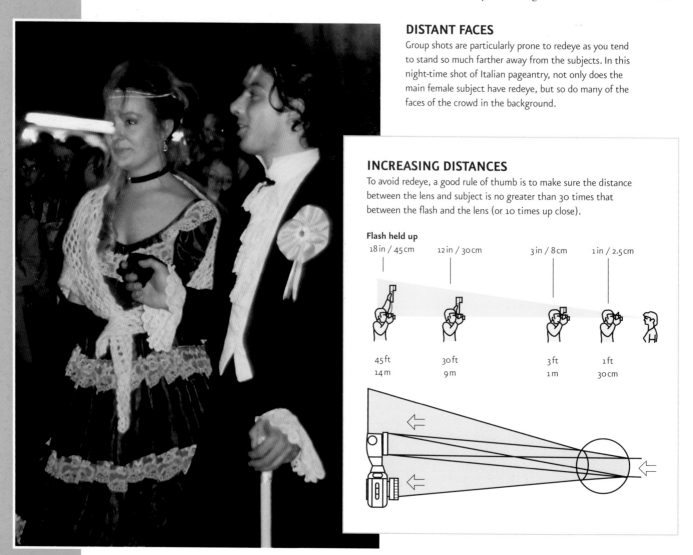

INCREASING DISTANCES

To avoid redeye, a good rule of thumb is to make sure the distance between the lens and subject is no greater than 30 times that between the flash and the lens (or 10 times up close).

Flash held up

18 in / 45 cm	12 in / 30 cm	3 in / 8 cm	1 in / 2.5 cm
45 ft	30 ft	3 ft	1 ft
14 m	9 m	1 m	30 cm

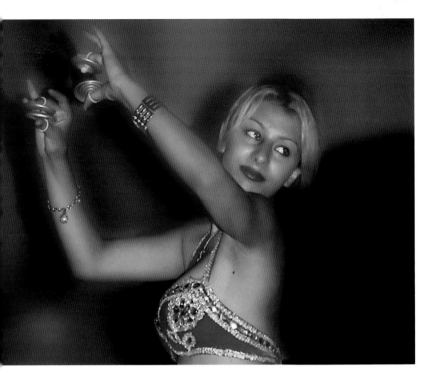

Most flash units provide special modes designed to minimize redeye. Obviously the angle between the flash and the lens doesn't change, so all they can do is reduce the effect, not eliminate it. They do so by using the light from the flash. A series of preflashes is used to force the pupils of the subject's eyes to contract before the shutter and main flash is fired. The end result is good as the amount of reflected light, and therefore the amount of red in the eye, is reduced so that it can become unnoticeable. However, a huge disadvantage is the time the system takes, and it can be two or three seconds between pressing the shutter and the exposure being made. This delay rules out spontaneity, can prove annoying to subjects, and prevents taking quick sequences. Another alternative is to use digital correction after the fact. Some cameras can even perform this without a computer.

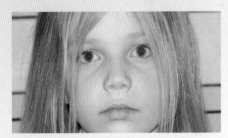

Normal flash mode

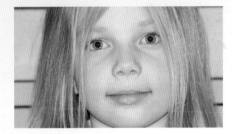

Redeye reduction flash mode

REDEYE FLASH MODE

These two shots were taken with a 200mm telephoto setting in almost total darkness. With normal flash the girl's irises are totally dilated and the redeye is extremely noticeable. Using the camera's redeye reduction mode reduces the size of the pupils so the redeye is far less noticeable.

the camera, the availability of longer and longer zoom lenses make it all too easy to stand that much further away from your subject when using flash, decreasing the critical angle to a point where redeye is inevitable.

In the digital era, a blood-colored pupil is not the end of the world, and it can be corrected easily with even the most basic digital manipulation software.

However, while this is useful, it is possible to avoid the issue altogether. The most obvious solution is to use an add-on flash unit rather than a built-in one. Even a hotshoe-mounted flash will usually place the flash tube significantly higher above the lens than any built-in flash unit (even SLR pop-ups), allowing you to stand much further away and still take advantage of longer focal length zoom settings. Taking the flash off-camera, by using a bracket, increases the distance (and critical angle) even further.

In situations where you have no alternative but to use the built-in flash, the simplest way in which to avoid redeye is to get closer to the subject and use a wider zoom angle.

SEEING RED

Shot from around 15 feet (5 m) away, this close-up of a Turkish belly dancer in action was taken with an SLR's built-in flash. The unavoidable redeye could easily be removed using image-editing software.

Slow-sync flash

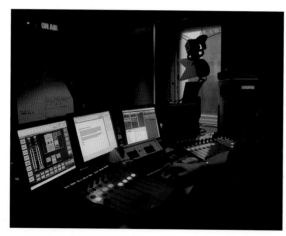

Slow-sync flash—2 seconds at f16

One of the disadvantages of portable flash is that it can easily kill the atmosphere. Low-light scenes are often photogenic because of the patterns of shadow and brightness that are created by the existing, ambient light. Use flash, and the subtlety of the nuances—especially in the foreground—is quickly lost, so a choice needs to be made between using the existing light alone or sacrificing some of what you see in order to gain more detail through a shake-free shutter speed or a lower ISO setting.

However, there is a midway option that allows you to combine the sharpness of flash while retaining some of the atmosphere of the original ambient lighting. This is done using a technique known as "slow sync."

STUDIO LIGHTING

For this shot of a radio DJ, the control screens and mixer lights needed to be exposed correctly. An ambient light exposure was taken to discover the rough exposure needed for the console alone. The disc jockey was then lit separately with a wireless flash that had a newspaper folded around it to form an impromptu snoot. This ensured the light from the flash lit the DJ alone, and not the control console.

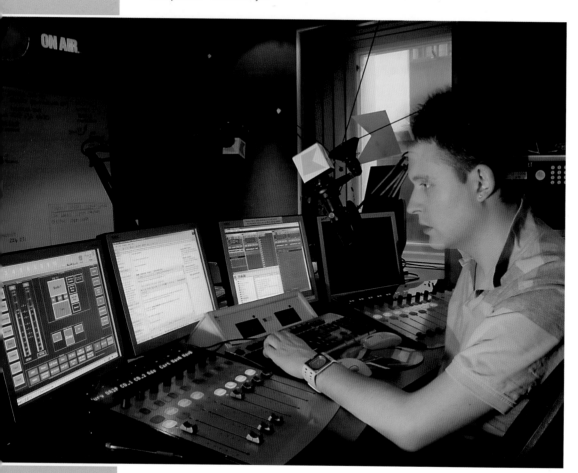

No flash—2 secs at f22

Normal flash—1/60 sec (f2.8)

As the name suggests, the idea is that you simply use flash with a slower shutter speed than you would normally do. In low light, increasing the shutter speed will have little effect on the part of the scene that is lit by the flash, but it can dramatically alter the rest of the image. As with fill-in flash, altering the shutter speed affects the brightness of the background, and if the shutter speed is long enough, areas that are not lit by the flash can be seen clearly. As these are often illuminated by a light with a different color temperature to the flash, these more distant areas gain a color cast. Although this could be corrected, often it will add to the ambience of the scene.

Many cameras have a special mode for setting the correct shutter speed for the ambient light, while still handling the flash metering for you. However, it is often worth experimenting with different settings to get the balance that you want in the image. Taking an ambient light reading, using the camera's built-in matrix or center-weighted metering mode, will tell you what is a good starting point for the shutter speed, based on the aperture needed for the flash exposure.

Slow-sync flash—1/2 sec (f6.7)

The shutter speed that is actually needed is almost inevitably slower than that required to keep the camera steady, or to freeze subject movement. However, the main subject is frozen by the burst of flash in much the same way as when using fill-in flash for sports. Unlike a daytime sports shots, the ambient part of the exposure creates a blurred, ghost image that feathers the edges of the sharp, central image in exciting ways, unless of course you use a tripod to keep everything sharp.

SHOW CAVES
Slow-sync flash (above) allows more of the ambient lighting arranged around the back of the cave to pick out the ribbon stalactites and stalagmites. This is achieved because the flash is providing less of the light than the ambient light.

Slow-sync effects

Slow-sync flash is not just a clever compromise between ambient lighting and flash, it can be a powerful special effect in its own right. The longer the exposure used with flash, or the more the subject moves while the shutter is open, the more dramatic the blurred halo between the two parts of the exposure becomes.

If photographing a moving figure, such as a dancer, the parts of the body that move most during the exposure become translucent in the image, showing the room behind as if they were never there. Areas of the body that move little or not at all during the exposure are frozen sharply and opaquely. Admittedly, with many subjects it is impossible to predict exactly how they will move

during the exposure, so the results can prove slightly unpredictable, and the longer the exposure, the less predictable the outcome. Longer shutter speeds can capture light trails as a bright background for a flash-lit foreground, and traffic moving during a 30-second exposure, for example, can create a dramatic backdrop for a portrait.

GLOWING EDGES

Slow-sync flash can be combined with other effects to create powerful abstract images. Here the close-up of the guitarists is captured using the camera's built-in flash combined with a shutter speed of 1/4 sec. In Photoshop, a semitransparent duplicate layer uses the Glowing Edges filter to give a stronger outline to the flash-frozen elements.

INVISIBLE MAN

The speed of this breakdancer's leg means that his jeans appear semi-translucent in this slow-sync shot taken with an exposure of 1/5 sec.

ZOOM BURST

You do not need to rely on subject movement to create interesting effects with slow-sync flash. It is possible to add blur by using the camera to create movement. One of the best ways to do this is to zoom the lens during the exposure. By changing the focal length as the exposure is made, the background will appear to explode in a sea of radial lines. The trick is only possible with a manually controlled zoom, and it is best to start zooming just before you press the shutter release. A shutter speed of between 1/8 sec and 1/2 sec is ideal.

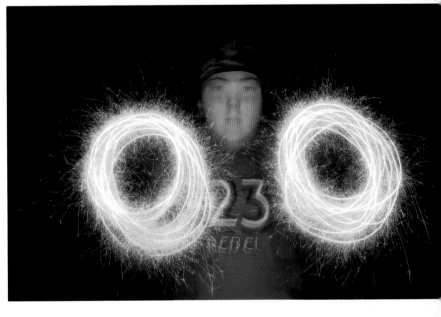

MANUAL CONTROL

Slow-sync flash is used here to bring gaming to life. The 2 second exposure creates a ghostlike halo around the fingers and keys.

FIREWORK DISPLAY

Sparklers were used to create the circular light trails in this portrait. An exposure of ten seconds was used with a hotshoe-mounted flash.

Rear-curtain sync

Although slow-sync flash produces interesting and worthwhile results in many lowlight situations, it can produce some bizarre and unwanted side effects with some moving subjects.

The problem arises when the moving object is travelling in a straight line across the frame. Shoot using slow sync, the blurred part of the image appears to overtake the frozen part, which creates an unnatural effect.

The phenomenon is caused because with standard flash, the flash unit is fired as soon as the shutter is fully open, so the frozen image is created at the beginning of the long slow-sync exposure, while the blurred image is recorded throughout the whole exposure. The final image ends up looking as if the blurred part has overtaken the main, flash-lit subject.

Many cameras offer a facility that gets around this problem by allowing you to set the flash to fire at the end of the exposure, rather than at the beginning. This is called rear curtain sync, or second-curtain sync, and rather than the flash firing when the first shutter curtain is fully open, it is discharged just before the second curtain starts to move to end the exposure.

Second-curtain sync sounds like the ideal setting for all slow-sync speeds, but there are good reasons why the more usual first curtain sync is the default option. It is much harder to compose a second-curtain sync image because it is hard to predict exactly where the subject would have traveled to by the end of the exposure. A runner, for example, may have moved out of frame during the time, so the flash will not reach its intended target. Even if you have the subject still in frame, the facial expression or pose may not be as you had hoped.

With most subjects, it is therefore best not to use second curtain sync, as you can fire the shutter and ensure the best pose and position for the frozen part of the image. The rear curtain sync mode is only worth using when the subject is moving in a predictable, predetermined line, or you need a very definite sense of forward motion.

POKER CHIPS

In this shot of chips being thrown onto a poker table, a slow shutter speed of 2 seconds was used with a brief burst of flash. Both second- and first-curtain sync were tried to see which gave the best result. As the blur created was only slight, the difference between the two was unimportant in the end. This is the second-curtain sync version.

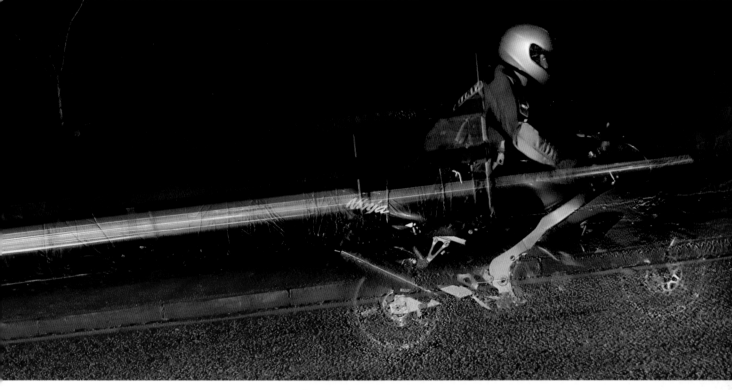

Second-curtain sync

FIRST AND REAR CURTAIN SYNC

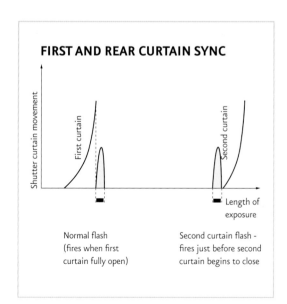

First curtain

Second curtain

Shutter curtain movement

Length of exposure

Normal flash (fires when first curtain fully open)

Second curtain flash - fires just before second curtain begins to close

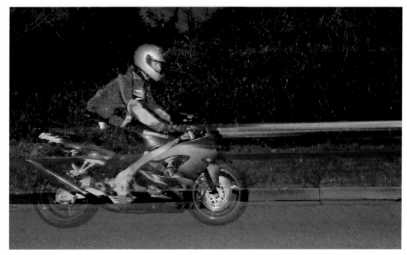

First-curtain sync

FOLLOWING THE LIGHTS

In this classic demonstration of the advantages of second-curtain sync, the motorcyclist was shot using flash in conjunction with a 1 second exposure. With normal, first-curtain sync (bottom), the streak created by the bike's red and white lights appears in front of the frozen subject. With second-curtain sync (top), the lights trail the Kawasaki, which gives a more natural appearance of forward motion.

Painting with light

The range of subjects you can photograph using portable flash is limited by power and coverage. However, in lowlight you can increase the effective guide number of the flash by firing it more then once during the exposure. Fire a flash a flash at its maximum output twice and you effectively double the light output and therefore its guide number. Fire a flash four times in the right direction and you double the area illuminated.

This multi-flash technique is known as "painting with light," which is also a term applied to scenes lit by a moving handheld torch. It is particularly useful for photographing large buildings after dark, especially their facades. With the camera held solidly in position on a tripod, a very long shutter speed is set. Somewhere between 20 seconds and 2 minutes is typical. On some cameras these exposures can be dialed in directly, while on others the Bulb or "B" setting needs to be used, together with a lockable cable release.

While the shutter is open, the flash is fired a number of times to ensure enough light reaches the whole of the subject. Although the initial flash could be synchronized with the shutter opening, subsequent flashes need to be hand triggered. For this, a flash unit with an "open flash" or "test" button is needed.

For the best coverage, it is often necessary to walk around during the exposure to get the flash to extreme corners, or highlight particular features. Care must be taken not to light yourself up—dressing in black is a good idea—and it is essential the flash is never pointed directly at the camera.

The number of times you will be able to flash during the exposure will vary on how fast your flash recycles between shots, so a fresh set of batteries would be wise. It is possible, of course, to use two or more flash units with test buttons in turn to help increase the total amount of light that you can add during the time exposure.

SECONDHAND FLASH UNITS

As with all photographic equipment, there is a healthy market for secondhand flash gear. Ebay, collector's fairs, and specialist dealers allow you to buy older flash units at a fraction of the cost that they would be new. Portable flashes are often more affordable than other accessories

While many were designed for older cameras and have trigger voltage compatibility dangers when used on a hotshoe, they are ideal for painting with light as most of these older flash units have a test button. Even on a small budget, you can therefore pick up a powerful flash or two for use solely when painting with light.

TEST BUTTON
The open flash button on a secondhand flash that cost less than ten dollars in a yard sale. It came complete with a wide-angle diffuser, rechargeable cells, and an AC adaptor.

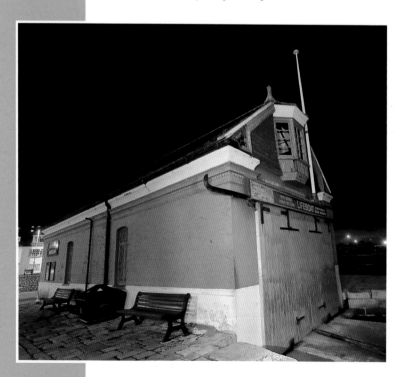

TRIPLE FLASH
Although one side of this old lifeboat station was well lit by lights on the quay, the slipway doors were much darker. A flash was fired three times during a 15 second exposure to even out the illumination.

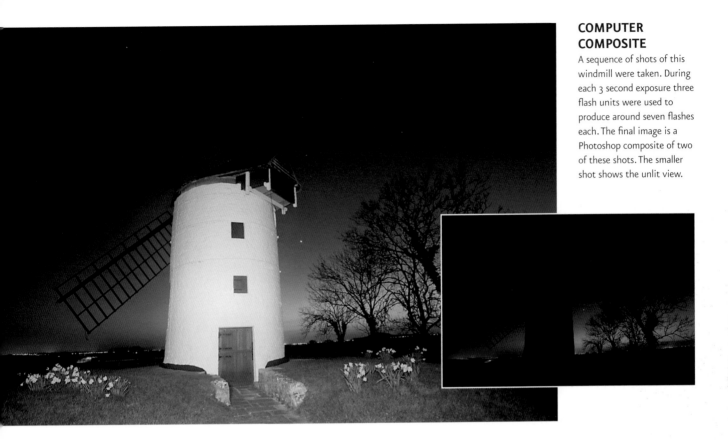

A sequence of shots of this windmill were taken. During each 3 second exposure three flash units were used to produce around seven flashes each. The final image is a Photoshop composite of two of these shots. The smaller shot shows the unlit view.

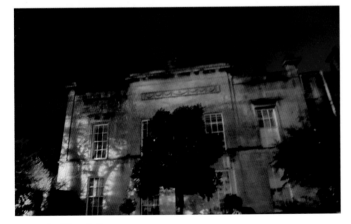

30 seconds without flash

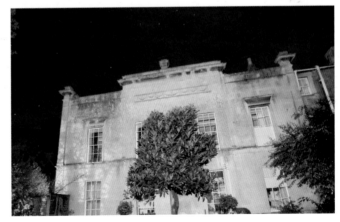

2 seconds with two flashes

MANSION

This old building was partially lit by nearby streetlamps, but on their own this gave rather uneven lighting to the facade. A flash was fired at one end of the structure, then fired again pointing towards the other end.

Multi-flash setups

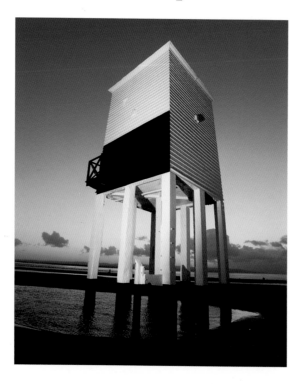

Portable flashes are designed to be used on the move and without too much effort, and as such they are most often used alone. However, it is perfectly possible to deploy several of these handheld flashes in unison to create sophisticated lighting setups. With miniature softboxes, umbrellas, handmade snoots, and other modifiers, it is possible to create many of the lighting effects that are more usually achieved using bigger, bulkier studio lighting.

Using two or more flash units together allows you to light subjects more evenly than you can with a solitary unit. But as well as increasing coverage, it also gives you the power to deliberately light certain areas of the scene differently.

ALTERNATIVE APPROACHES

The dedicated wireless systems made by camera manufacturers are not the only way of being able to fire remote flash units without the use of trailing wires. In low enough light, it is possible to use flashes with built-in or add-on slaves which fire when they "see" the master flash being fired. However, slaves may have problems syncing with devices that use preflash.

An alternative is to use a form of radio trigger, such as the Pocket Wizard range (*www.pocketwizard.com*). These have the distinct advantage that flash units will fire even if they are not in the line of sight of the controller unit.

MINI SLAVE
This small, self-standing flash unit has a built-in slave, so it fires automatically when the main flash goes off.

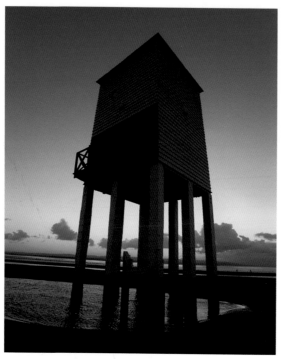

TWO-FACED FLASH
At low tide you can walk to this old clapboard lighthouse, but it is not possible to light the whole structure with one flash. Instead a high-powered hammerhead unit was held by an assistant to light the left-hand side, using 12 feet (4 m) of cable to get as close as the composition allowed. The right face was lit using a less powerful wireless flash unit, held at arm's length by the photographer.

It is possible to connect multiple flash units using cables and connecting sockets, but wireless flash units have become an increasingly popular solution. Not only does working without wires allow you to be more adventurous with the position of your off-camera flashes, but dedicated wireless flashes can be controlled remotely by the camera. The camera will fire a "master flash," and this will trigger all the other wireless "slave" flashes using the cameras sophisticated TTL metering.

However, the cost of dedicated wireless flash units can be prohibitive. If you are prepared to work a little harder on your exposure settings then using inexpensive slave cells on less sophisticated flash units is far more economical.

DOUBLE BOUNCE

An ambient light shot of this conservatory throws the furnishings into shadow. Using a wireless flash to bounce into the near right-hand corner, and a wired flash to bounce off the ceiling to the left of the camera, produces a more balanced interior. (Both shots were taken at 1/20 sec at ƒ8, but the bottom shot uses two bounced flashes added).

WIRELESS FLASH

Wireless flash not only allows you to synchronize the firing of a remote unit, it can also allow you to use it while retaining a high degree of dedication, so the exposure is controlled automatically.

The wireless systems work by using a "master" flash to send the necessary commands and settings to the remote flashes. A series of flashes, similar to the preflashes used for measuring exposure or controlling redeye, sends the coded instructions to the other flash units. These semaphore-like instructions are usually provided by the SLR's built-in flash, or using a hotshoe-mounted flash unit or controller.

Different flashes and cameras offer varying degrees of sophistication. Some offer two or three channels, allowing you to control the lighting ratios between different units (or even groups of units). Others offer a modeling light so that you get a visual preview of the lighting setup.

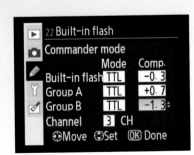

WIRELESS STAND

Wireless-compatible flashes usually come with feet so they can stand on any flat surface.

CENTRAL CONTROL

This Nikon on-screen menu allows you to control the relative output of each wireless flash from the camera itself.

Ring-flash and macro

Due to the limited range of flash, being close to the subject is usually an advantage. Ironically, however, the closer you get, the less suitable standard flash units become. With macro subjects, where your subject may only be a few inches from the front of the lens, built-in flashes, hotshoe units—and even most of the off-camera flash solutions— will fail you.

When using a macro lens or extension tubes, additional lighting almost becomes inevitable. The camera and photographer themselves are likely to throw the subject into shadow, and the extension needed between lens elements and digital sensor means that the closer you focus, the more light the exposure requires.

Normal flash solutions will not work as the lens shields the subject from the flash light, while a single off-camera flash positioned to the side creates such strong side-lighting that important detail is almost inevitably lost.

A specialist flash unit is therefore used to overcome these difficulties. The lighting source is attached to the front of the lens (using the screw thread usually employed for filters), while the capacitor and controls are housed separately and attached to the hotshoe. Dedicated versions in particular, make macro photography extremely straightforward, and are widely used by scientific and medical photographers.

Two different designs can be bought. A ring-flash has a circular flashtube and diffuser that encircle the front of the lens. The alternative is a twin flash arrangement that uses a pair of miniature flash tubes either side of the lens.

Both macro flash solutions provide an even, almost shadowless light that is ideal for many macro subjects. The maximum output is very low compared with most other flash units, with a typical guide number of 46 feet (14 m) at ISO 100. However, as the light source is so close to the

EVEN LIGHTING
A ring-flash provides soft lighting that is ideal for this macro shot of a slipper orchid.

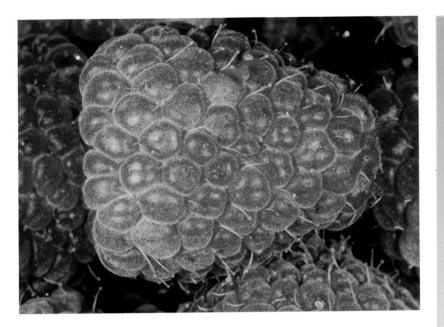

FASHION ACCESSORY

Ring-flashes are not just built for macro work, giant versions are also used for portraiture. Studio ring-flash units are popular with many fashion photographers as the ring of light not only produces halo-shaped catchlights in a model's eyes, but also creates a rim of shadow around the subject's head. The even lighting creates a flat, bleached face that makes the accessory less than useful for more traditional portraiture.

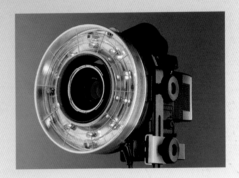

subject, this is more than adequate, even when using the smallest apertures that a macro lens offers (typically ƒ32 or ƒ45). These flash units usually have a greater range of manual output settings, providing a minimum setting that can be as low as 1/64 of the maximum power available.

An advantage of the twin flash solution is that the output of each tube can be separately controlled so a degree of modeling can be added to the scene. A ring-flash, on the other hand, produces donut-shaped catchlights that some photographers favor.

NOT SO SOFT

Despite its positioning, a macro flash unit gives fairly harsh lighting. Here the twin tubes create distinct highlights on each segment of the raspberry, and the fruit in the background are noticeably darker due to the fall off of the light.

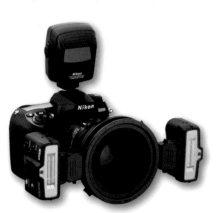

TWO-ARMED APPROACH

This Nikon macro flash uses two tubes that attach either side of the lens.

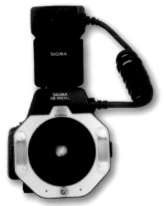

HYBRID SOLUTION

A Sigma twin-flash uses a circular diffuser to merge ring-flash and twin flash effects.

CIRCLE OF LIGHT

Using a Broncolor ring-flash creates even, shadowless lighting across the model's face and creates a circular catchlight in her eye.

Chapter five
STUDIO FLASH

Setting up a studio

Shooting in a studio allows the photographer to be in complete control. The ability to adjust the lighting and the background means that images can be constructed in a way that is usually impossible with portable flash on location.

A studio does not need to be a purpose-built room. In fact, many rooms and garages can be temporarily converted to studio use without too much disruption or remodeling. However, the amount of space that is required is much greater than most beginners would realize. The exact dimensions are, to a certain extent, dictated by the size of the subject itself (small items can be shot on a small table or bench, for example), but the space around the subject is also crucial.

The distance from the camera to the subject is also dependent on the focal length of lens you are using. For portraits and product photography you will normally want to avoid extreme wide-angle settings as short telephoto focal lengths provide a less distorted image of the person or object. However, this will require a larger space.

Just as important is the distance between the subject and the background. The greater the separation, the more scope you have for throwing the backdrop out of focus and, just as importantly, the more room you have to light the background and subject separately. When photographing people, the distance from them to the background should ideally be at least three feet (about a meter).

Studio lights with stands are big, bulky items. Their large footprints mean that the width of the room is also important. In a narrow room it is harder to keep lights and reflectors out of shot, and this also gives you less scope to reduce their output by moving them further away.

A certain amount of room behind the camera is also needed—not only for the photographer to work comfortably, but also to accommodate the flashes and stands that provide frontal lighting.

Typical home studio setup

Blackout blinds on window

Backdrop (a roll of paper supported by its own pair of stands) extends across floor to make a "scoop," so foreground and background merge seamlessly

Space to side and around camera to position lights

HEALTH AND SAFETY

A studio is a mass of trailing wires that lead to heavy lights on what can be less-than-completely-stable stands. Photographers, assistants, and subjects can easily trip, bang heads, or end up with equipment falling on top of them. There is also the real risk associated with working with electricity and red-hot bulbs and flashtubes.

Don't wait for an accident to happen. Do what you can to minimize the dangers from the start, such as taping down leads, and keeping the floor as clear of unnecessary camera bags and cases. Warn those in the studio of potential risks.

Background unlit Background lit

LIGHT AND DARK

These two shots are taken using the same light blue sheet of card. It is curved in a "scoop" so that it forms the surface the subjects sit on as well as the background. But its color, and gradation of tone, can be controlled using lighting.

A room that measures at least 15 ft long and 12 ft wide (5 × 4 m) is ideal for portraiture. However, it will still be a squeeze for full-length portraits or for large group shots.

In order to avoid the color cast problems created by mixed lighting, any windows should have efficient curtains or blinds. Failing that, blackout material can be temporarily used. It is best that walls, floors, and ceilings are white, black, or gray—again to avoid unexpected color casts.

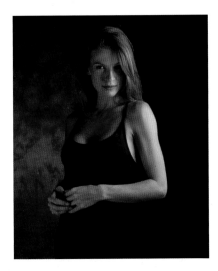

COLORFUL SKIES

Patterned backgrounds that create stylized versions of dramatic skies are a popular alternative to plain colors. This purple backcloth, called New York, is made by Lastolite.

BACKGROUNDS

Backdrops are commercially available in a huge range of colors, fabrics, and designs.

Paper rolls are popular if you want to use plain colors, including black and white, because when a section becomes dirty or creased it can be cut off and thrown away.

For backdrops that are to be used again and again, it is worth paying close attention to how crease-resistant they are, or how practical it is to iron them. Wipe-clean or machine-washable backdrops are also advisable, particularly with lighter colors.

The tones and colors of a backdrop, given enough space, can be largely controlled by lighting. A white backdrop can be made to look black if it is unlit, and can be converted to any hue with the use of colored gels.

Get the biggest backdrops that you can accommodate, as this provides more flexibility with camera angles. Ironically, the smaller the room, the larger the backdrop may need to be—because the wider focal lengths you will need to use in the space provide a greater angle of view that takes in more of the background.

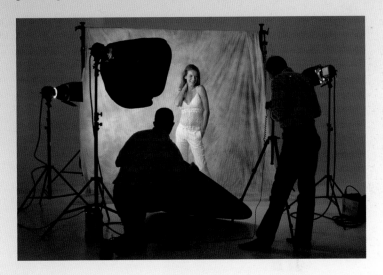

Backdrop supports
In a permanent studio, a backdrop is usually supported by a wall-mounted rail. A free-standing background support such as this—comprising of a pair of stands and a crossbar for suspending the fabric or paper roll—offers a more maneuverable solution.

Tabletop studio

Many subjects that you might want to photograph with studio flash do not require full-size backdrops. Whether shooting a product for sale on the internet, or capturing creative still life setups, a table is often more than adequate for arranging both subject and background.

With studio lights in particular, you will still need a reasonable amount of space around this tabletop studio to maneuver stands and position reflectors, and to get the tripod into the perfect position. However, unlike the portrait studio, the amount of room required means that this small-scale setup can be incorporated into practically any room.

Backdrops are much easier to cope with on a small scale as a large sheet of paper or piece of fabric can simply be draped over a box or a pile of books to create the necessary scoop behind the subject. Many subjects can even be photographed from a high enough angle so that a vertical expanse of backdrop is unnecessary—the surface that the subject is placed on becomes the border and background to the image.

GOLDEN GLOW
These cod liver oil capsules were lit with an impromptu still-life table—resting them on a sheet of white Plexiglas, with the light positioned underneath to provide backlighting.

OLD CAMERA
This old camera was shot on the floor. A velvet throw is the backdrop, and the camera is raised slightly using a small box under the throw. A Benbo tripod holds the taking camera steady in a low-angle position.

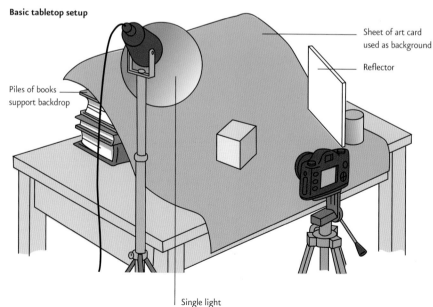

Basic tabletop setup

Piles of books support backdrop

Sheet of art card used as background

Reflector

Single light

Studio on the floor
The floor is ideal when you do
not have a table big enough

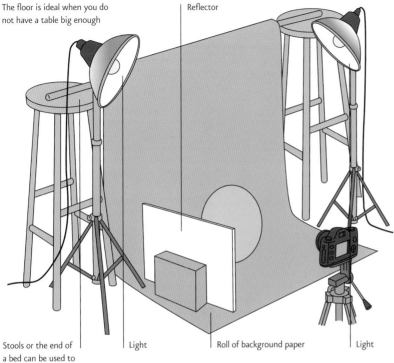

Reflector

Stools or the end of
a bed can be used to
support the backdrop

Light

Roll of background paper

Light

For a colored or black background, velvet is an ideal choice as it avoids problems with reflections. White is popular for product photography as it gives a clean surround for overlaying type or for creating cutouts (or silos, as they are often known). However, to achieve a bright white background in a tabletop setup, the surface ideally needs some form of underlighting. For this reason, specialist still-life tables are often used.

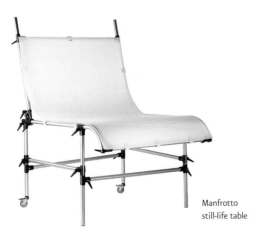

Manfrotto
still-life table

SHOOTING TABLES

Shooting tables, or still-life tables, are purpose-built for small-scale studio photography. They are made from a curved sheet of white Plexiglas (Perspex), which creates a clean white backdrop against which to shoot cut-out subjects. The translucent material means that the subject can be lit from behind and/or underneath to brighten the backdrop. Other backdrops can be draped or clipped over the table if different colors or patterns are required.

LIGHT TENTS

A common problem with product photography is that the shiny surfaces of the subject reflects the lights you are using. Although diffusing the lights can solve the problem, highly reflective subjects can end up mirroring the camera, tripod, and other studio paraphernalia that surround them.

A popular solution is a light tent, in which the whole subject is surrounded by diffusing material. This softens the lights, which are placed outside the tent, and just a small opening is allowed for the camera lens.

Few light tents have the flexibility of size or design to be ideal for all subjects. Cone-shaped tents, which have no corners, are the best commercial solution. However, it is perfectly possible to make your own light tent out of white cotton or nylon sheeting.

Without light tent

With light tent

LOSING REFLECTIONS

This antique brass hairdryer was difficult to photograph as the polished metal reflected the photographer, tripod, and lighting. Surrounding the subject with a white sheet solved the problem. The white material drained the brass's color, but this was simple enough to add back in later using Photoshop.

Lighting ratios and modeling lights

With studio flash, you don't have the automatic metering options that are available with portable flash. It is the photographer who manually sets the flash output and the chooses the appropriate exposure settings.

Of course, the power provided by an individual studio light can be adjusted, with the number of output settings varying greatly depending on the model. However, this is not the only way in which output can be controlled. Just as important is the flash-to-subject distance. A good-sized studio provides you with the space to move the light further away in order to change its effect on the subject. Even in a tight space, the effect of distance is significant. Simply moving a light from three feet (1 m) away to six feet (2 m) away will reduce its effective power by 75 percent.

The third factor in the power equation is the type of light modifier used. Studio lights are rarely, if ever, used in "bare bulb" form, but will often have one or more attachments to control the spread of light, or to diffuse the output. The vast range of attachments that are regularly used in a studio can be deployed to regulate the power provided, as well as adjust the characteristics of the lighting.

Using these three controls together is made easier with a modeling light. This tungsten or halogen bulb provides a continuous light that gives a visual preview of the lighting adjustments that you are making, giving you an idea of what the shot will look like when the flash is actually fired. The modeling lights are also invaluable for providing a working light source for shot arrangement and focusing.

Better-quality lights allow you to adjust the modeling light proportionately to its power setting. However, modeling lights are not a perfect way of judging the setup. They can guide changes to position, and help you see problematic reflections and the like, but the ultimate way to check is to take a trial shot with the camera. Looking at this shot, in conjunction with its corresponding histogram

CHANNELING THE LIGHT

The spread of light can be narrowed still further than is possible with a reflector, using more specialist light-shaping and controlling accessories.

For a relatively narrow beam, a conical-shaped reflector with a black interior, known as a snoot, is used. The spread of light can also be adjusted by the use of barn doors, which consist of two or four hinged flaps that fit in front of the light itself (or another modifier such as a softbox or reflector). These can be angled to avoid light spilling onto areas where it is not wanted. Often, however, light spill can be controlled in an *ad hoc* fashion by using pieces of black card—known as flags—held in the correct position using clamps or duct tape.

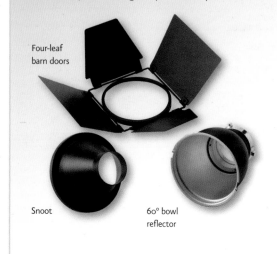

Four-leaf
barn doors

Snoot

60° bowl
reflector

MEDIA INTEREST

These blank CDs were photographed using direct light from two studio lights placed either side of the table. Reflector bowls were fitted to both to minimize the spread of light outside the subject area. The position and height of the lights was adjusted to create the most interesting rainbow patterns on the recordable surface.

and highlight/shadow clipping warnings, will give you a far better idea as to how the position, power setting, and diffusion can be further adjusted to get the result that you require.

The intensity of modeling lights becomes important when shooting portraits. The brighter the ambient light, the smaller the pupils of the eyes become, which can lead to an unflattering picture. The most photogenic results are when the pupils are dilated.

SPOT OF COLOR

The main light in the setup below is from a snoot above, and behind, the watermelon. This provides backlighting for the red flesh. A second fill light to the right of the camera is then added to fill in some of the shadow areas.

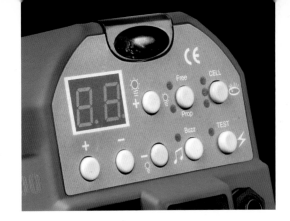

MODELING ADJUSTMENT

Studio flash heads typically provide a separate modeling light control, which allows you to set their brightness to change in proportion with the flash power currently set.

Snoot alone

Snoot with fill light

REFLECTOR BOWLS

For direct, undiffused lighting, studio flashes are usually fitted with reflectors. This can be a confusing term, as the flat panels used to bounce light back into shadow areas are also known as reflectors.

Also known as bowls, spill kills, or dishes, these reflector attachments are usually made of aluminum. They limit the spread of light from the flash, to ensure there is no problem with flare, and control the direction. The silvered interiors are shaped so as to bounce any "stray" light in the right direction.

Bowls come in a wide variety of diameters and depths, providing a range of coverage angles, with wider dishes offering a comparatively softer output to narrower ones.

Standard reflector, providing a 65° light spread

Narrow reflector, providing a 45° light spread

Wide reflector, providing a softer light over a 78° angle

Single light setups

Getting the lights in the right position is of paramount importance in studio photography. Relatively small changes in the height or angle of a lamp can make a critical difference to the strength and direction of the highlights and shadows in an image.

Although a studio image may be lit with four or more lights it is quite possible to light many subjects with just a single flash. What's more, even if you are using multiple lights, there is usually one main light that sets the way that the subject is lit. Positioning this "key" light, as it is known, is arguably the first thing you should do when setting up a scene. Other lights, as we shall see in subsequent pages, are essentially there to reduce contrast by filling or eliminating shadows, or lighting secondary elements within the scene, such as the background.

Given the cost of studio lights, many people may start out with just a single flash, but even if you own several flashes it is always worthwhile experimenting with using just one to start with.

A single light source in a studio tends to produce dramatic, contrasty images, as there is none of the natural fill-in that you would usually get with sunlight (although fill-in can be added by the use of reflectors).

The strong shadows that are created with most subjects make the single light more suitable to some subjects than others, and this is traditionally a better way of creating

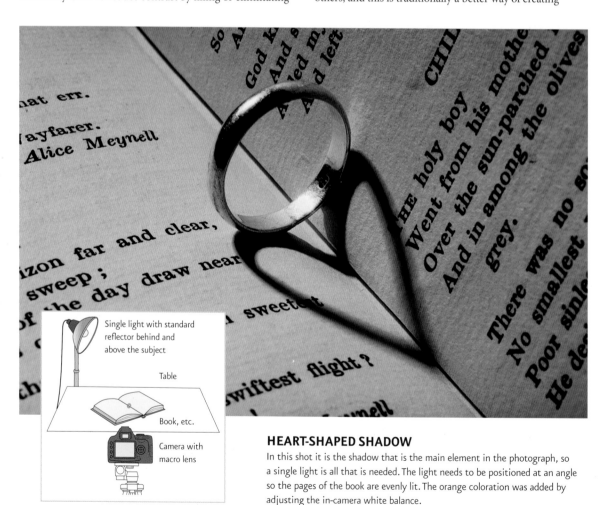

HEART-SHAPED SHADOW

In this shot it is the shadow that is the main element in the photograph, so a single light is all that is needed. The light needs to be positioned at an angle so the pages of the book are evenly lit. The orange coloration was added by adjusting the in-camera white balance.

Single light with standard reflector behind and above the subject

Table

Book, etc.

Camera with macro lens

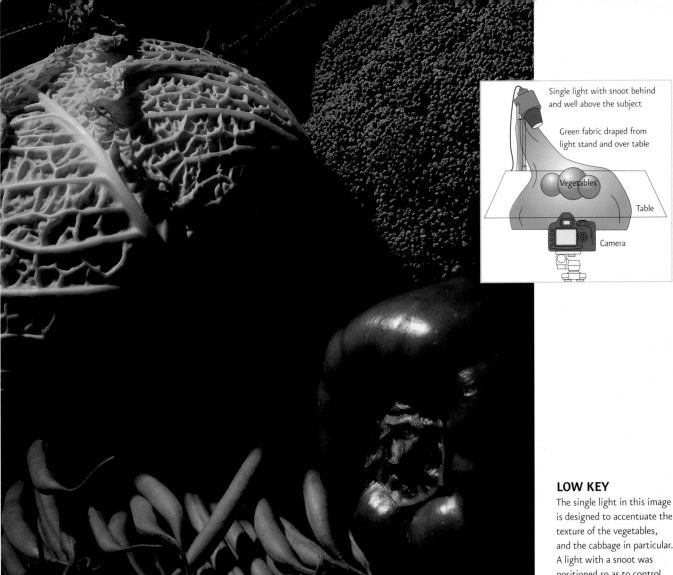

Single light with snoot behind and well above the subject

Green fabric draped from light stand and over table

Vegetables

Table

Camera

LOW KEY

The single light in this image is designed to accentuate the texture of the vegetables, and the cabbage in particular. A light with a snoot was positioned so as to control the areas that were lit. The dark, low-key approach is similar to that seen in Old Master oil paintings.

a strong character portrait of a man than a romantic portrait of a woman. However, it can also be an artistic choice to create a stronger look.

When placing a light, learn to look at the effect that its position is having on the subject. Look to see which areas are brightly lit, which are half lit, and which are in deep shadow. Try and develop an idea of how these areas will be recorded by the camera rather than how they look to the eye, remembering that the camera operates with a smaller contrast range.

See the elements of the subject that are emphasized. How are shape, form, texture, and color conveyed? Set the height of the lamp first, and then alter its position gradually. Always check the setup through the viewfinder, rather than from where you happen to be standing—the small differences in viewing position can be crucial. Having an assistant move the lights for you can greatly speed up the process, and remember that even with a single light you can alter spread and diffusion with modifiers and other flash attachments.

Softening the shadows

The difficulty with a one-light studio setup is that it inevitably creates large shadow areas where detail is lost or hard to make out. Although this dramatic type of lighting suits some subjects, it is less than ideal for most. However, there is no need to use additional lighting in order to reduce the contrast. The shadows can be filled simply by reflecting light back from the single light you are already using.

This form of reflector is arguably the least expensive, yet most useful accessory that you can have in a studio. A simple sheet of white card is often more than sufficient to bounce light back into the darker corners of the scene and the amount of light that is reflected will depend on the material the reflector is made from, its size and its distance from the subject.

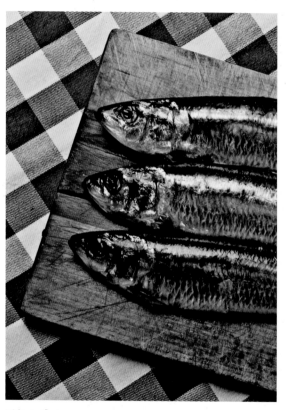

Without reflector

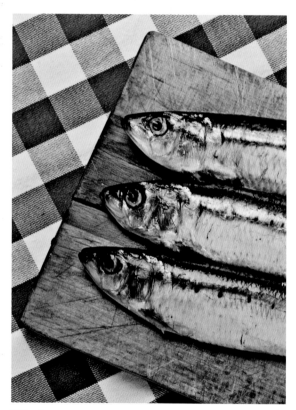

With reflector

AND FIVE LOAVES

Lit with a single large softbox, the sidelit sardines are rather too gray. Adding a large sheet of white card as a reflector dramatically changes the image, creating a much more accurate image of the silvery fish.

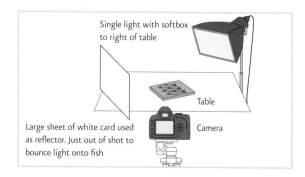

Single light with softbox to right of table

Table

Large sheet of white card used as reflector. Just out of shot to bounce light onto fish

Camera

1/200 sec at ƒ27 with flash
At the normal flash sync speed the screen looks blank. However, this allows you to work out the aperture needed for the flash exposure.

4 secs at ƒ27 without flash
Experimenting with long shutter speeds reveals the best exposure to bring out detail in the screen and backlit trackball.

A flash's modeling light is invaluable for positioning the reflector. The starting point is on the opposite side of the subject to the light itself. Tilting and rotating the reflector at different angles can increase or lessen the effect, so look carefully at the shadows, and see how they are lightened. With the reflector in the right position the effect can be very significant.

Whether you use home-made or purchased reflectors, holding them in the right position as you check the exposure and take the actual pictures can be difficult. Having an assistant is the simplest solution, but you can make do by propping reflectors against pieces of furniture or a spare studio stand.

LCDs and LEDs

Whether a product photographer is shooting an MP3 player or a microwave oven, the areas of the image that often come out darker than expected are the gadget's own lights. Information screens, status indicator lights, and colorful diodes are often the most visually exciting part of a device, but with the brief duration of a studio flash exposure all the color and brightness can be lost from these LEDs and LCDs.

Although the ambient lighting in a studio is kept subdued to avoid problems with mixed lighting, a fast

4 secs at ƒ27 with flash
Combining the two parts of the exposure provides a shot that offers detail in the screen and the cellphone body.

shutter speed means that total darkness in unnecessary. It also means that a tripod is not always essential.

To get an electronic gadget's own lights to show, however, the shutter speed needs to be increased and all ambient light cut out. With film, the solution was usually to make a double exposure, but as this is not possible with most digital cameras, slow sync flash is used, typically combining a shutter speed of several seconds with the camera locked in position on a tripod.

Types of reflector

Most commercially produced reflectors are designed for portability. Ingenious feats of engineering are used to create a large flat surface that can be folded away to practically nothing for easy transportation.

Although such reflectors have their place in the studio, they can often be an unnecessary expense, and if one is bought, it often turns out not to be large enough. As a rough guide, a reflector should be at least twice the size of the subject it is bouncing light back onto. A 2 ft (60 cm) circular reflector is large enough for a closeup of a face, or for many still life setups, but for full-length portraits, a 6 × 3 ft (2 × 1 m) rectangular reflector is much better. Such large reflectors are known as "flats" and while you can buy them with collapsible pole frames and stretch-over fabrics, it is just as easy to make your own.

A white sheet of this size, for instance, is often available in most homes, is easily stored away and transported, and can be held in position using poles or wires. For something that can be maneuvered into position more precisely, a thick piece of polystyrene could be bought and cut to size.

Alternatively, you can use a thin piece of plyboard painted white on one or both sides. An advantage of this approach is that if (and when) the reflector gets dirty, it can simply be given a fresh coat of paint. Feet can also be made for such panels, so they can be held in position. In a commercial studio, such flats are often put on wheels, so they can be slipped in and out of the set with the minimum of effort.

The surface finish and material that is used will affect the reflectivity of the panel (see box), but its effect on the subject is just as dependent on its distance from the surface that it is lighting. Moving the reflector closer to the subject will greatly increase the fill-in effect of the reflector, while correspondingly subtler effects can be achieved by moving the reflector further away.

GOLDEN TOUCH

Lit with a single snooted studio light, a gold reflector adds detail to the vase and reduces contrast in the petals, while adding a warm glow to the image.

No reflector

With gold reflector

No reflector

Reflector at 1 ft (30 cm)

Reflector at 2 ft (60 cm)

Reflector at 3 ft (1 m)

PANEL POSITIONING

The distance that a reflector is from the subject determines how much the shadows are softened. At 1 ft (30 cm), the white reflector makes a striking difference to this single softbox shot. At 3 ft (1 m), the effect is much more subtle.

PROJECTION SCREEN

This Interfit gold reflector screen is designed to fold away when not in use.

MATERIAL CHOICE

Mirror
Even brighter than a silver reflector.

Aluminum foil
Makes low-cost silver reflector. One side has higher reflectance than the other. Reflectance can be further reduced through crumpling.

White cotton sheet
Average reflectance, with the advantage that it can also be used as diffuser. Hard to hold in position.

White card
Average reflectance.

Polystyrene
Dimpled surface creates lower reflectance than most other materials. Very light, but easily damaged.

Foamboard
Thicker than card, more robust than polystyrene, and more reflective than both. Available from specialized art and signage suppliers. Also known as Foamex, Foamcore, Gatorfoam, foam PVC, etc.

Painted plyboard
Any lumber sheeting will do, but thinner is better as it keeps the weight down. The finish of the wood will affect the reflectance, as will the type of paint. A smooth, sanded finish and gloss paint will produce the highest reflectance.

PICK A COLOR

Although white reflectors are easy to make yourself, gold and silver reflectors may be worth buying. Silver reflectors give a sparkly quality to the light, while gold or bronze reflectors add a warm glow to the reflected light that can be useful for giving a more tanned look to a portrait subject's skin.

Black reflectors are also widely used by studio photographers to place dark reflections in very reflective subjects, such as glassware.

Twin light setups

Moving from a single light to a pair of flashes means the subject can be lit more evenly. With two lights, coverage can be given to sides of the subject that are facing in different directions, to a degree that is not usually possible using reflectors.

CURVED SURFACES

Bottles, vases, and jugs are ideal subjects for photographers to practice their skills on—just as they are for the painter. The curved surfaces allow you to explore the way that different light positions and degrees of modification affect the final image.

One light

Two lights

A pair of lights is the standard setup for lighting any subject where relatively even illumination is required. They work as a team, with each softening the shadows that the other creates. This sort of lighting is used as a basis for traditional, non-dramatic portraiture as well as most straight product photography.

The lighting from the two lights, however, does not have to be completely even. The advantage of studio lights is that the relatively intensity of each can be so easily changed. This can be done by reducing the power output of one of

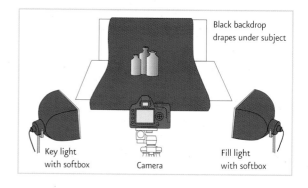

Black backdrop
drapes under subject

Key light
with softbox Camera Fill light
with softbox

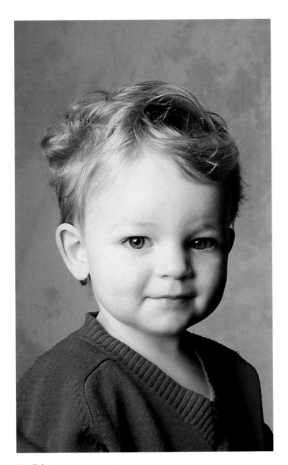

One light

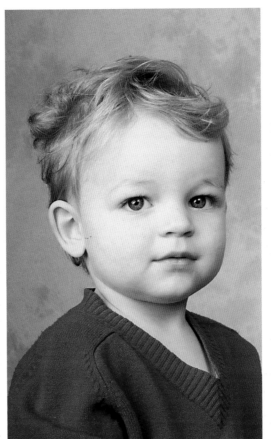

Two lights

A single light from an umbrella placed close to the camera produces what at a glance is a good, dramatic portrait of the toddler. However, it has resulted in a strong shadow along the side of the nose. Adding a second, weaker light, again bounced into an umbrella, creates a much more even effect.

the lamps, by placing it farther away from the subject, or by adding more diffusion. The weaker of the two lights is known as the "fill" light, as it provides fill-in for the main "key" light.

When lighting a face, it is usual to put the key light slightly to the side of the camera, but high above it. This recreates the sort of natural light you get if the sun is behind you at the beginning or end of the day. It also has the advantage of ensuring that the eyes are adequately lit.

The second light is then placed on the other side of the camera to soften the shadows created by the key light, and to reduce the overall contrast. Both lights are kept reasonably close to the lens axis, however. This both prevents accentuating any wrinkle lines and also ensures that both lights create distinguishable catchlights in each eye.

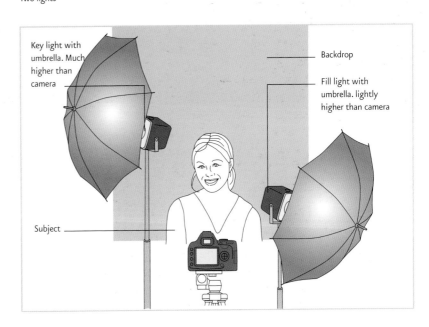

Key light with umbrella. Much higher than camera

Backdrop

Fill light with umbrella. lightly higher than camera

Subject

Multiple light setups

It is possible to light most subjects with just two lights, but occasionally, when photographing automobiles, for example, a bank of lights may be necessary to produce diffuse, even coverage over a large enough area. However, even groups of people can usually be lit with the strategic placement of two studio flashes.

At the same time though, additional lights can prove useful even with small-scale subjects or with single models. A third light is often used to provide an accent to the subject, revealing something that is not shown by the main key light and fill lights. Most commonly this accent light is used to provide a source of backlighting.

A light hidden directly behind a solid object can be used to provide rimlighting, where the light provides a glowing halo to highlight the object's outline.

In portraits, backlighting is often added using a spotlight or snoot to add an accent to the model's hair. This hairlight, as it is known, is particularly impressive when photographing people with light-colored hair. But it is not just a useful technique with blondes, as the small pool of light on the hair can help to separate a dark-haired subject from a dark studio background, thereby avoiding the outline of the head merging with the backdrop.

A backlight is also a sensible addition when photographing a subject with translucent elements, and particularly when the backdrop is dark or unlit.

USING A HAIRLIGHT

In this shot a third studio light is used to spotlight the hair of the model. The backlighting is provided by using a special focusable light that has a built-in fresnel lens.

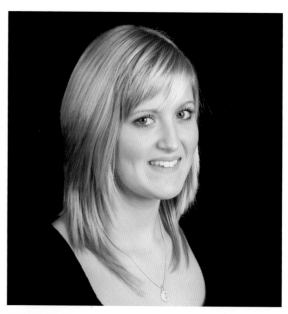

Without hairlight

With hairlight

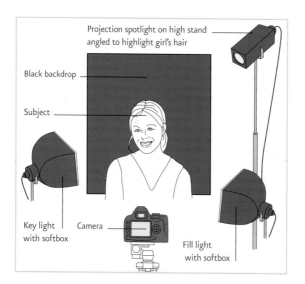

Projection spotlight on high stand angled to highlight girl's hair

Black backdrop

Subject

Key light with softbox

Camera

Fill light with softbox

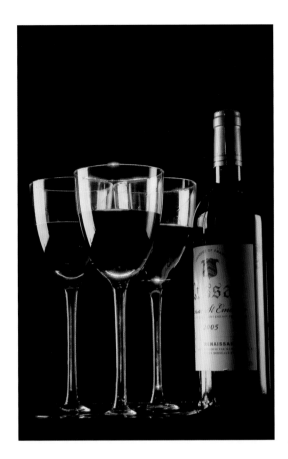

LIGHTING THE BACKDROP

Having three or four lights to work with is extremely useful for lighting the backdrop. While the subject itself can be adequately lit by a pair of flash heads, a further pair of lights will often be required to light the background evenly.

Special low stands are often used to get these lights in position, and they are placed well to the side of the visible backdrop to help make sure coverage is as even as possible. A single light, placed high or low, however, can be used to create a graduated backdrop from one that is uniform in color.

ALTERNATIVE VIEW

Setting up the lighting for shots like this takes a lot of time, as you gradually get equipment and props in the right place. But once they are set up, making variations on the original shot takes relatively little extra work. This more abstract study of the wine glasses essentially uses the same lighting.

BACKDROP REFLECTOR

This special reflector bowl is designed to shine an oval-shaped pool of light over a backdrop. This creates a vignetted effect on the background. The cut-off shape of the bowl helps to prevent light straying in the direction of the camera. Clips on the bowl are used to attach gels.

SPLASH OF RED

In this shot, the subject is mainly lit by two large softboxes, which create pools of light in the glassware that help to define their form. However, this frontal light gives no color to the wine. Placing a low light behind the set-up table casts enough light upward to create a red line at the meniscus.

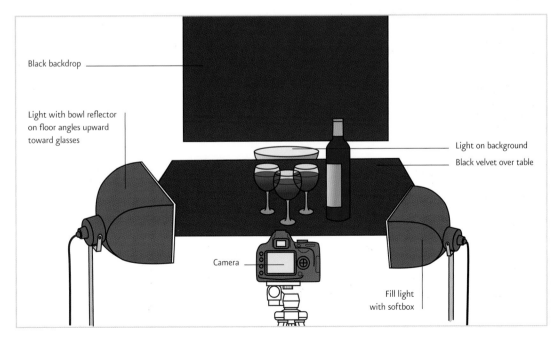

Black backdrop

Light with bowl reflector on floor angles upward toward glasses

Light on background

Black velvet over table

Camera

Fill light with softbox

Umbrellas

There are two main ways you can soften studio lighting. As with portable flash, either diffusion or reflection can be used to scatter the light and turn the harsh flash lighting into a softer, and more indirect, form. With studio lights, softboxes are commonly used to create diffusion, while many portrait photographers will use umbrella to reflect the light onto the subject.

For many subjects, there is little to choose between an umbrella and a softbox. Both are certainly well suited to classic portraiture, and can be used to provide the soft light that is so often needed in product photography.

The advantage of an umbrella is that it is so easily erected and dismantled, not to mention being considerably less expensive than a softbox.

Like a rain umbrella, the fabric dome can be folded away to a straight stick that takes up very little room, and when in use its construction is such that the reflected light is efficiently concentrated on the subject.

The shaft of the umbrella is inserted into a tubular hole that runs through the whole lamp head, or alternatively fits through a specially provided external attachment. A locking clamp keeps the umbrella in place and allows you to vary the distance between the flash tube and umbrella.

The interior of a bounce umbrella is light-colored, while the outside is black to prevent any light transmitting through the nylon fabric. A white interior is the most usual color, although silver and gold are also available. As with reflectors, silver umbrellas create a brighter reflection, while gold adds warmth to the color of the reflected light. Reversible umbrellas, or umbrellas with interchangeable inserts are also available.

All-white "shoot through" umbrellas are also available. These are translucent, so they can be used to either bounce light back toward the subject like a standard umbrella, or as a diffuser, with the light pointing directly at the subject and the umbrella positioned between the two.

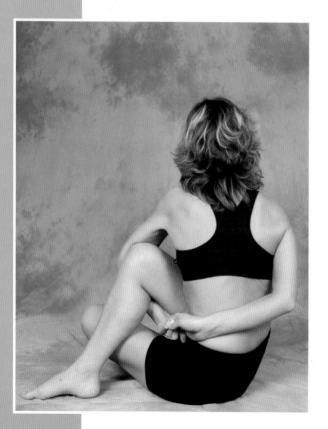

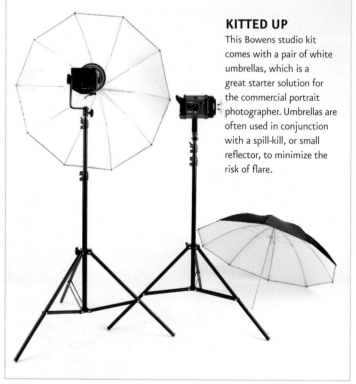

KITTED UP
This Bowens studio kit comes with a pair of white umbrellas, which is a great starter solution for the commercial portrait photographer. Umbrellas are often used in conjunction with a spill-kill, or small reflector, to minimize the risk of flare.

YOGA SERIES

A series of pictures commissioned for the launch of a new program of fitness classes. Each shot was taken with a white umbrella as the key light, with a higher gold umbrella being used for fill when needed.

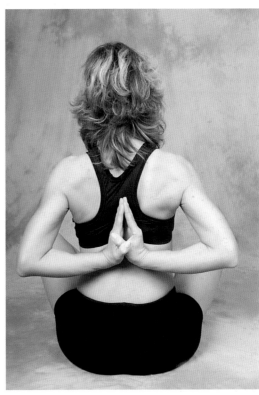

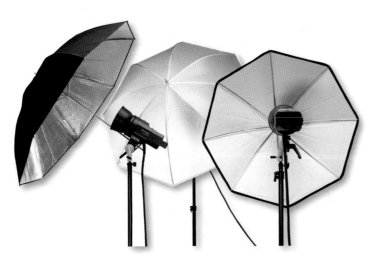

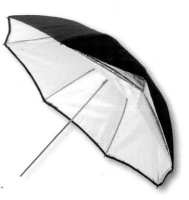

TWO IN ONE

This umbrella (right) has a removable outer cover, so it can be used as a silver umbrella for bounce flash, or as a white translucent umbrella for diffused direct light.

TYPES OF UMBRELLA

These are three of the umbrellas available in the Broncolor range: silver (left), translucent white (center), and standard white (right).

Softboxes

Softboxes are designed to produce a diffuse, but direct light. They are essentially boxes, one side of which is a large, white translucent panel that is placed some distance in front of the flash tube. They create a soft, relatively controlled light with the added advantage of distinctly shaped catchlights depending on the shape of the softbox.

Softboxes are tent-like structures, and putting one together with its grid-like structure of poles and fabric panels may remind you of going camping. Although many are collapsible, the process is not usually quick, making you reluctant to take it to pieces between each shoot. On the other hand, softboxes are large items—often very large—so they take up a lot of space when fully constructed. There are some models that are designed to be more portable (such as the Lastolite Ezybox), and conversely, some of the top-of-the-range softboxes do not come apart at all.

In addition to the front white diffuser panel, most have a second diffuser—or "baffle"—midway inside the box. By using one or both diffusers, the degree of diffusion can be altered, but in reality, many photographers soften the output from their softboxes still further by attaching layers of "scrim," which are sheets of diffusing material such as netting, white cotton, fleece, or bubblewrap. Honeycomb grids can also be attached to restrict the spread of light. When it comes to choosing a softbox it's worth noting that the diffuser will yellow with age, and replacement parts are easier to source from better-known brands.

The bigger the size of the softbox, the more diffuse its output, and the better its suitability for larger subjects. Ideally, the size of the softbox should be at least equal to that of the subject, and should be used as close to the subject as possible. In reality, a 24 in (60 cm) square softbox is more than adequate for a head-and-shoulders portrait, while a 36 × 24 in (90 × 60 cm) rectangular softbox can be used successfully for full-figure work. Since they contain largely nothing, softboxes aren't particularly heavy for their size, but as they protrude some way forward from the flash they can make the light front-heavy and possibly unstable. To prevent the stand from falling over, it may need to be counterbalanced.

GROUP PORTRAITS
The diffuse, even light created by softboxes is ideal for group portraits, as shadows would further complicate the composition. In this shot, a large reflector in front of the camera and a hairlight were also used.

JARGON
Softboxes are given a variety of different names, both internationally and by different photographers. These are some of the more colorful terms you may come across:

Fish fryer
A softbox mounted on a boom.

Light bank
Giant softbox that uses multiple flash heads to light large subjects such as automobiles.

North light or Window light
Term used because softboxes create a window-like light, as used by painters who traditionally have studios with windows that face north.

Swimming pool
Extra large softbox.

Wafer
Shallow softbox using curved struts, as made by Bowens.

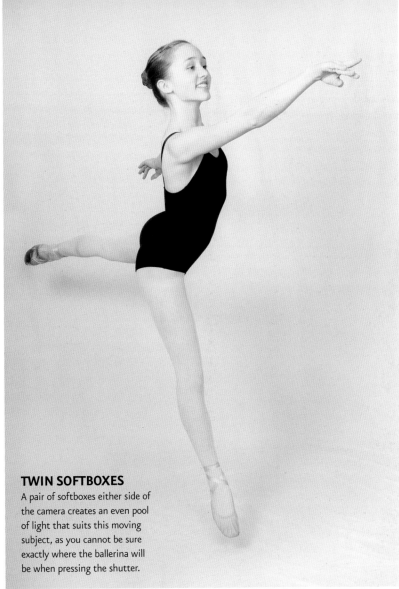

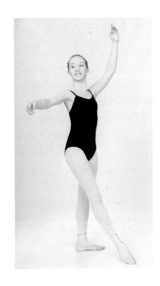

BACKLIGHT WITH TWIN SOFTBOXES

For a static shot, a more complex lighting setup can be used. In addition to the two softboxes, a third light is placed behind the backdrop. This is shielded from direct view by the dancer's body.

TWIN SOFTBOXES

A pair of softboxes either side of the camera creates an even pool of light that suits this moving subject, as you cannot be sure exactly where the ballerina will be when pressing the shutter.

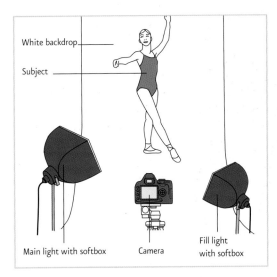

White backdrop

Subject

Main light with softbox Camera Fill light with softbox

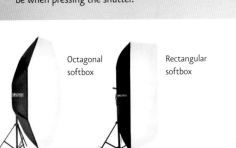

Octagonal softbox

Rectangular softbox

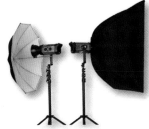

DIFFERENT SHAPES

Softboxes come in different shapes as well as sizes, as these two huge Elinchrom attachments show. The shape is often chosen because of the shape of catchlight that it will create.

ISSUE OF SIZE

A softbox is bulkier and slower to construct than an umbrella, and is significantly more expensive to purchase, but many photographers prefer them as it is easier to control the light.

CONSTRUCTION

Softboxes have a silvered inside and a black exterior. The white front diffuser will yellow with age, and poles can snap, so it is worth buying from a manufacturer that sells spare parts.

Snoots, spots, and gobos

Dramatic studio lighting often requires the photographer to concentrate the light on a particular area, rather than diffuse it to gain the most even coverage. It is the photographic equivalent of using a spotlight to light a theater stage, rather than a floodlight. Although sometimes used on its own, this beam-like form of lighting is most usually deployed as an effects light to highlight a particular part of the subject, or to provide an element of backlighting.

The most usual tool for photographic spotlighting is a snoot. This conical attachment funnels the light into a small front aperture, greatly restricting the spread of light (typically providing a 15° coverage). This is particularly useful in a small studio, as it allows you to light your subject independently of the background or foreground, even where the depth available for shooting is restricted.

A snoot, however, still produces a beam with a diffuse edge, not the hard-edged pool of light that is associated with a theatrical spotlight. For a sharper-edged pool of light a special type of light or attachment is used that projects the light over an adjustable area. This is constructed

ROOM WITH A VIEW
Making your flash look more like window light is easy if you project the right pattern of glazing bars over the scene. Here different gobos are used with a projection spot to provide different patterns.

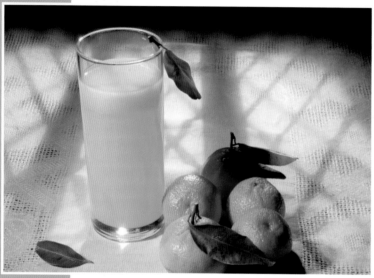

Lattice

Eastern

French doors

Sideways lattice (using same gobo)

STUDIO FOR HIRE

Few photographers have the space or money for all the equipment they might ever need. So even professionals regularly hire equipment and studio space as required for a particular shoot. Hiring a studio for an hour or half a day can allow any photographer the chance to try studio photography on a larger scale, and to use the different equipment and backdrops on offer. Renting from a dealer specializing in professional photography allows you to use esoteric pieces of equipment, such as a projection spot, at the fraction of the cost they would be to buy.

Honeycomb attachment for a snoot

HONEYCOMBS

A honeycomb or grid is a mesh-like device that is used in front of a bowl reflector, snoot, or softbox. The honeycomb pattern is designed to reduce the spread of light.

using a ribbed lens, known as a fresnel, which allows the light to be focused onto the subject. The photographer has complete control over how hard or blurred the edges of the beam are, while a variable aperture allows you to control the width of the spot.

Such spotlights are available for some studio systems that use separate capacitors, or may be available as reflector-style attachments that you can fit to your existing studio flashes.

SNOOT

Although snoots can be cylindrical, most are conical in shape.

SPOT ATTACHMENT

This projection lens attachment can be used on most modern Bowens lights.

GOBOS AND GELS

Gobos, or cookies as they are also known, are cut-out masks that are designed to project a pattern of light and shade over a subject. Normally made out of aluminum, these patterns can be used to create the silhouetted shapes of window frames, stars, foliage, clouds, logos, and countless other patterns that can help set the scene or add atmosphere.

Gobos fit into purpose-made slots on spotlights, and by using the provided lens adjustments their projected image can be made larger or smaller. These are most easily bought from theatrical and cinema lighting suppliers, but can also be hand-cut from thick card.

Gels are colored sheets of acetate that can be used over lights to correct color temperature, or to add color. They are often used with a spotlight, often in conjunction with a gobo, to create a certain mood.

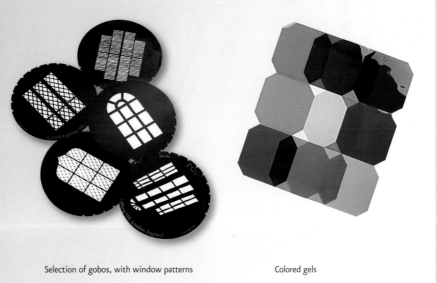

Selection of gobos, with window patterns

Colored gels

Flat subjects

In some ways, photographing a painting or a baseball card is much like shooting any other subject. However, flat, two-dimensional pieces of artwork create particular challenges, especially if you want to create as accurate a reproduction as possible.

This form of photography even has its own name—rostrum photography—which dates from the days before color photocopiers and scanners. A scanner is now the most obvious choice to produce a digital image of a piece of artwork, but the size of most flatbed scanners imposes a limit on the size of material we can scan. They are also not a solution for framed pictures, as the artwork must be in contact with the scanner's platen.

Lighting is, as ever, crucial. The surface not only needs to be lit extremely evenly, it also needs to be set up so that there are no surface reflections. The usual way to do this is to have the artwork resting flat on the ground or table, with two lights either side, angled at 45° to the subject's surface. There are lights sold commercially for this purpose. Alternatively, you may already have everything you need in your flash equipment, as a pair of softboxes, or umbrellas, can produce an even enough light source. Finally, it is crucial that the camera is positioned directly above the artwork. If the back of the camera is not parallel with the artwork, the sides of the rectangular subjects will not be parallel, resulting in a keystone effect.

COPYSTANDS

Copystands, or repro stands, are specifically designed for photographing artwork. A baseboard with a grid is provided for lining up the subject and a column with a movable camera platform is fitted perpendicular to this. A tripod screw is provided for attaching the camera, and the platform can be smoothly raised and lowered to adjust camera distance and magnification.

A low-cost alternative is an old darkroom enlarger. If you remove the enlarger's head and lens assembly the chassis will provide a very similar device with baseboard, column, and adjustable platform. Thanks to the rise of digital photography, used enlargers can now be found cheaply.

Kaiser copystand

CLOSE VIEW

A copystand is particularly useful for small subjects, allowing you to focus a macro lens precisely to capture all the detail of items like postage stamps.

A simple trick to check that the lights are positioned evenly to either side is to stand a pencil or pen upright on a piece of white paper in the middle of the camera's field of view. You then take a test shot with your setup. If your lights are balanced, then the two shadows will be of equal lengths, equally gray, and at 180° to each other. Using the highlight clipping display will also help you see whether the flash brightness is even over the whole surface.

The pencil test
The idea of this test is to get the shadows perfectly matched on either side.

STRAIGHT LINES

This shot of an old Belgian advertisement was shot with two softboxes to either side of the artwork. The difficulty in the setup was aligning the Benbo tripod to ensure that the image was perfectly rectangular.

RESTORATION WORK

Rostrum techniques are useful for making digital copies of old prints that are missing their negatives. This portrait is about 100 years old, and is starting to show signs of wear. The copy was shot through the glass frame to prevent further damage. Discoloration and marks could then be touched up in Photoshop.

Natural light

Flash

REFLECTIONS

These collector card albums show the problems of using natural light to photograph artwork. The shape of the windows can clearly be seen in the covers. Careful positioning of flashes, however, creates a much cleaner result.

High-speed photography

High-speed photography reveals a secret world of events that are normally invisible to the human eye. It produces spectacular pictures of moments such as a bullet tearing through a playing card, or the split second when a chameleon whips out its snakelike tongue to catch an unsuspecting insect.

You may think that such pictures would demand specialist cameras and fast-fire triggering devices for their success, but although some high-speed photography may demand esoteric equipment, there are plenty of subjects that can be tackled with a normal camera. The secret—as you might have guessed—is the flash.

A burst of flash can be extremely short. Set on automatic at a close distance, a camera's built-in flash or a small hotshoe unit may have an output that is a short as 1/50,000 sec. When you consider that most enthusiast SLRs have a maximum shutter speed of 1/2000 or 1/4000 sec, and professional models usually 1/8000 sec, these flash durations are incredibly short. Such a brief burst of flash will freeze movement to show us things we couldn't with the eye, so with relative ease you can capture the incredible craters made when a drop of water hits a puddle, and the surrounding splashes of liquid, though you may find you need a bit of patience to get the timing just right. Mercifully, digital technology has made what was once a trial-and-error process virtually painless.

As you need to keep the ambient light level low, this is a studio technique, and you must have complete control over the surroundings. However, it is best not to use studio flash units. These typically have a flash duration that lasts a little less than 1/1000 sec, so the shorter duration of a portable flash set to a low power output or fired on automatic from a short distance is preferable.

Once you have the camera set up to shoot a drop of water, and the flash exposure is set correctly, the difficult part begins. You need to be able to fire the shutter so that it opens at the same moment as the splash occurs. The delay in the drop falling, the delay of your own reactions, and the delay created by the camera itself after you press the trigger all conspire to make the perfect shot hard to come by. But the advantage of digital imaging is, as ever, that you can keep on shooting until you get the frame you want.

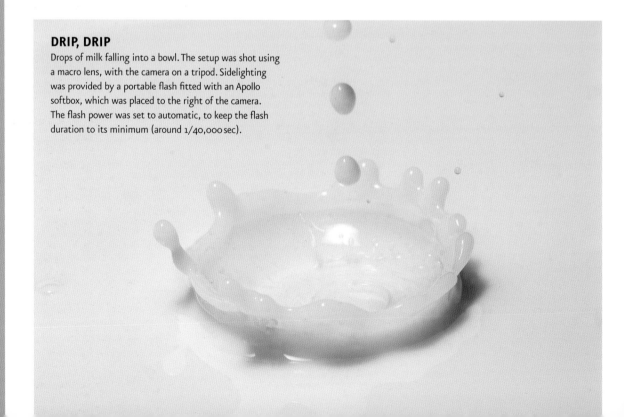

DRIP, DRIP
Drops of milk falling into a bowl. The setup was shot using a macro lens, with the camera on a tripod. Sidelighting was provided by a portable flash fitted with an Apollo softbox, which was placed to the right of the camera. The flash power was set to automatic, to keep the flash duration to its minimum (around 1/40,000 sec).

THREE-FLASH SETUP

A cube of ice falls into a glass of water, sending photogenic splashes across the frame. The main subject was lit using a single, diffused portable flash unit to the side of the camera. The flash power was set to its lowest manual setting to get the briefest flash duration. Two miniature slave flashes (each with a fixed guide number of 10) were used to light up the background, so that it looked white in the picture.

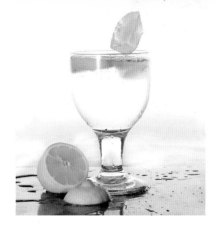

HIT OR MISS

The success rate with this setup was much better than with the milk splashes. However, there is always the risk of firing the shutter too early, and catching the ice cube suspended in the air, rather than hitting the water.

TRIGGERING DEVICES

A triggering device can help overcome the problem of slow reaction time. The device typically works using an infrared or laser beam, which, when broken, sends a signal to release the shutter. Many high-speed photographers build their own triggers, but commercial solutions include the Shutter-Beam (www.woodselec.com) and the Jama (www.jama.fr).

FASCINATING FACT

The typical delay between pressing the release button on an SLR and the shutter actually opening is around 1/15 sec (70 ms). The reaction time of a photographer—the delay between actually seeing the event and taking the picture—is around 1/5 sec (200 ms).

Repeating flash

George Bernard Shaw wryly observed that England and America are nations divided by a common language. This is particularly pertinent when it comes to flash photography, and the use of the word "strobe." While in America, strobe is another—albeit less common—term for a flash, the British stick to the word's scientific heritage, thinking of the fast-repeating "stroboscopic" flashing lights that are used at nightclubs and rock concerts.

The linguistic difficulty is compounded in that some flash units offer both forms of flash. High-end dedicated flash units often have a mode that allows them to repeatedly flash at a frequency where the flashes are visible to the human eye, while other modes such as preflash exposure metering and high-speed sync cycle the flash on and off at a rate that the eye cannot detect.

Nikon call this flash mode "repeating flash," Canon call it "stroboscopic flash," and Sony label it simply "multiple flash." Whatever it is called, it is used to provide a multiple

exposure image of a moving subject, reproducing two or more images on the one frame.

Although a slow shutter speed needs to be used, each of the individual constituent images is perfectly frozen. The technique has its scientific uses, enabling you to analyze the action of club and body during a golf swing, or to display the movement of a bird's wings during flight. The technique can have interesting creative uses too.

The facility may well be found on portable flash units, but to make the most of the technique you need studio conditions. The camera needs to be solidly supported, and a dark background is necessary if each flash image is to be seen clearly. You will be asked to set a frequency in Hertz (Hz), which is the number of times the flash fires per second. Slower settings in the 5–10 Hz range are usually best. The frequency used and the power setting will then dictate the maximum number of flashes the stroboscopic mode can last for, although this will be a few seconds at most.

Single flash firing: 4 secs at f11

Four flash firing: 4 secs at f16

POWER BOOST

With the lights on maximum power, an aperture of f8 was not sufficient to keep the far end of the hi-fi system in sharp focus. Using four flashes, the lens could be stopped down to f16, giving much better depth of field.

If the photographer needs a smaller aperture it is possible to build-up the level of exposure on the sensor by adding more and more light. Doubling the number of bursts applied increases the exposure by 1EV each time, so f22 is achieved with 8 flashes, and f32 would be reached with 16 flashes.

Fire Flash x 1	f8
Fire Flash x 2	f11
Fire Flash x 4	f16
Fire Flash x 8	f22

ADDING DEPTH

Firing the flash more than once can also be a useful technique for studio product photography. Close shooting distances and the depth of the setup to be photographed often combine to make it impossible to keep the whole product in focus. A smaller aperture is not an option, as the flash heads are already at their maximum power.

However, by using a long shutter speed in total darkness it is possible to fire the flash more than once, using the open flash button to fire the flash manually for the second and subsequent times. The technique is similar to painting with light, except here the multiple firings are used to increase the effective guide number of the flash, rather than coverage.

BOUNCING BALL

A golf ball creates a distinctive parabolic line as it bounces across a table. Shot with a Sigma ringflash, the repeating flash mode was set to 25 Hz with manual power at 1/32. This gave a maximum number of flashes of 14. These were fired during a one-second exposure at f18.

JUGGLING ACT

Stroboscopic flash with a handheld camera gives an interesting impressionistic image of the juggling skills of this jester.

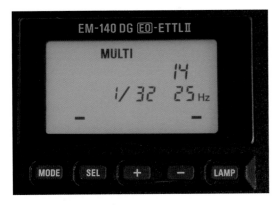

STROBOSCOPIC MODE

The stroboscopic flash settings for the golf ball image.

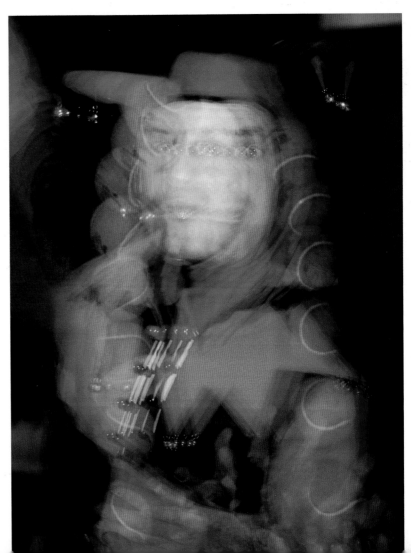

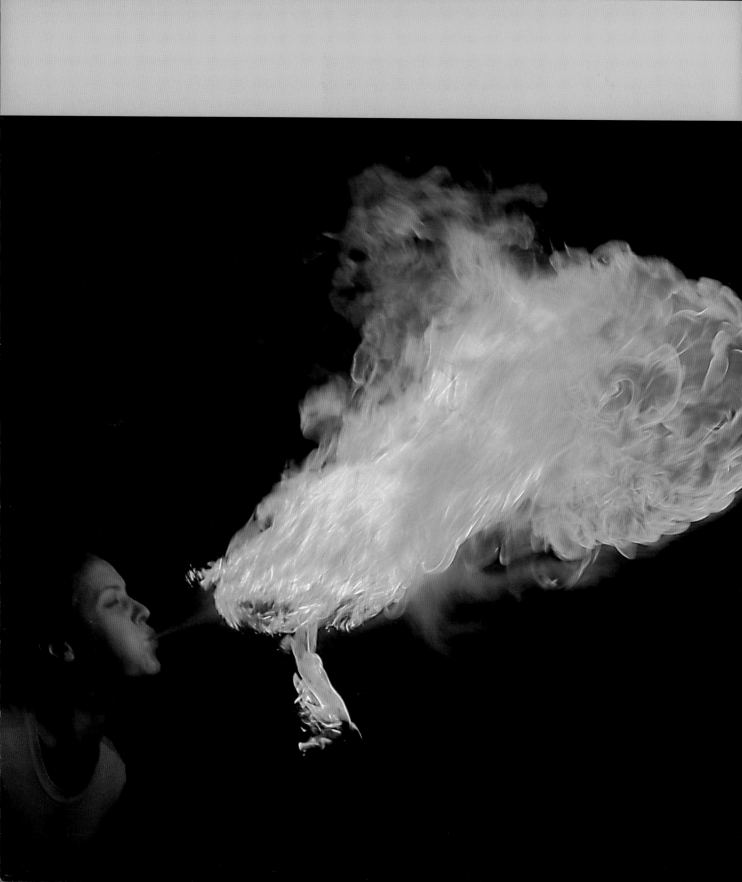

Chapter six
COMPUTER EDITING

Basic corrections

6

COMPUTER EDITING

In digital photography, taking the picture is only the start. The ease with which an image can be manipulated and adjusted on a computer means that post-production is an essential part of the creative process. It does not matter how well the pictures are taken, it is possible to make them a bit better using programs such as Adobe Photoshop. Some images, on the other hand, can be completely transformed by these "digital darkroom" techniques.

To a large extent, flash photographs can be handled using the same methods as you would use for any digital image. However, flash lighting can create its own problems and disasters. If you know that such defects and faults can be corrected using software manipulation, you will be encouraged to be more adventurous with flash photography in the first place.

The first step in "processing" a digital image is to adjust the exposure. As well as making the image lighter or darker, altering the contrast and tweaking the color balance can also be particularly useful for the flash photographer, where camera setting and metering errors are more likely than with ambient light photography.

Shooting in RAW, rather than JPEG or TIFF, allows you to make these corrections without affecting the original data, which is preserved alongside a list of your corrections. These need to be processed using a conversion tool before editing or saving in a conventional file format.

Converters such as Adobe Camera Raw (ACR), Adobe Lightroom, or Apple's Aperture provide sliders that alter the overall exposure, saturation, and color temperature. Most usefully, they allow you to alter the contrast range by stretching or contracting the exposure histogram to optimize the range of tones from the brightest white to the deepest black. These can be altered using the Brightness and Blacks sliders in the basic ACR manipulation screen, or a graph-like interface might be used, similar to that used for Curves adjustments.

Before

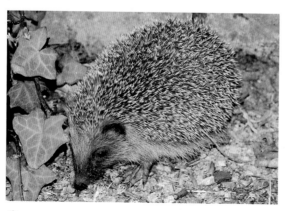

After

BLEACH JOB

This shot of a hedgehog has been bleached out, which is typical of a flash picture where the exposure is slightly out. Adjusting the brightness and contrast during RAW conversion allows you to "re-exposure" the picture with virtually no loss in quality or detail.

Curves is Photoshop's best tool for altering image brightness. This allows you to brighten shadows by pulling up a point of the graph line at its shadow (lower left) end or to reduce the brightness of highlights by pulling down the line towards the top right. Such corrections can be made at several points on the same graph, although the shape should not be too distorted or the results will look unnatural.

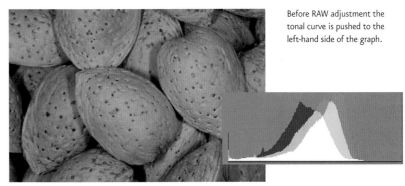
Before RAW adjustment the tonal curve is pushed to the left-hand side of the graph.

Before

Manipulating the curve. Corrections to the curves are best made on a separate adjustment layer so you can go back and fine-tune the result.

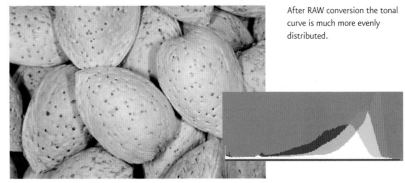
After RAW conversion the tonal curve is much more evenly distributed.

After

Final converted image

OUT OF THE BLACK

This portrait of a New England blacksmith has not received enough flash power, and the detail is lost in dark shadow areas. Pushing the curve up at two points in the shadow areas on the left makes the scene more visible. The curve is pulled down slightly at the highlight end on the right, to prevent the window from becoming too over-exposed.

WATCHING THE GRAPH

Making alterations in Adobe Camera Raw is a matter of looking at both the visual preview of the image itself and the histogram. This close-up shot is dark and lacking in contrast. The graph shows an absence of bright tones. This is corrected by pushing up the Contrast, Brightness, and Shadow sliders until the graph fills more of the available space, without any clipping.

Shadows and highlights

The harsh, high-contrast nature of flash means that the range of tones in an image is often simply too great for the camera's sensor to record. The result is that detail is lost in either the shadow or highlight areas, or both, meaning that dark areas become jet black, and bright highlights become an even, featureless white.

In an ideal world, you check the histogram of all the shots you take, ensuring that shadow clipping is minimized and highlight clipping is avoided. However, it is not always possible, particularly in situations where you don't have the chance to retake the shot.

Unfortunately, adjusting the exposure and contrast using Curves adjustments and basic RAW tools, can do little to save these areas where detail has been lost. Clipped highlights are particularly unresponsive to a simple reduction in the brightness of the lightest areas.

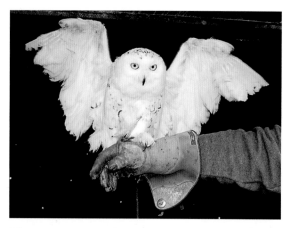

Before

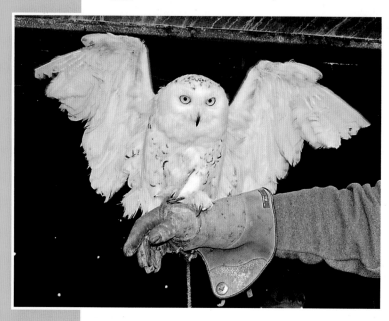

After

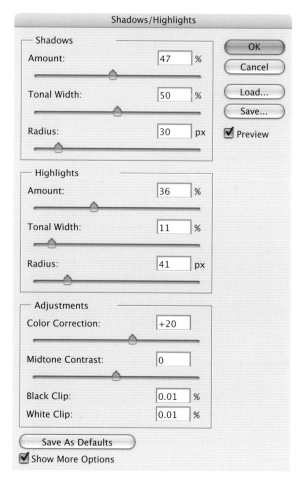

Adjustments used

RESCUED OWL

A flash picture of a snowy owl reveals a typically overbright subject and an overly dark background. Using the Shadow/Highlights command recovers a good amount of detail from white and black areas of the image.

However, Photoshop does have two intelligent tools for restoring lost detail in shadows and highlights. In Photoshop itself, there is the Shadows/Highlights adjustment, while in the latest version of Adobe Camera Raw, RAW files can be rescued in much the same way, by using the Fill Light and Recovery sliders. Both use sophisticated algorithms to make an informed guess as to the relative tones of the clipped areas and rebuild the picture with this in mind.

In earlier versions of Photoshop, the Shadows/Highlights adjustment was a destructive utility that had to be applied directly to a layer. This meant it could only be applied selectively using the History Brush or by masking a duplicate layer. From CS3, Photoshop now allows the tool to be applied like a Smart Filter. By converting the background layer to a Smart Object, you can not only turn the Shadows/Highlights adjustment

off as if it were a separate layer, but you can also use a mask, allowing you to apply the correction selectively, and then go back and edit this selection later.

The Recovery and Fill Light sliders in Camera Raw offer fewer options as to how the highlight and shadow rescue is applied, but you have the advantage of working on a RAW file, so there is no risk of data loss even as you edit simultaneously with more traditional exposure and contrast adjustments. You can also overlay a highlight clipping warning to give a visual guide as to how much Recovery needs to be applied.

Both tools should be used sparingly though. Heavy-handed use can result in some areas of the picture looking unrealistically flat, so don't expect miracles. You can gain valuable detail in the darkest and brightest areas of your flash image, but—like any digital tool—they cannot rescue an image that is substantially over- or under-exposed.

MAKING A SPLASH
Adobe Camera Raw's Recovery tool cannot fill in the specular highlights created by flash, but it can reduce their intensity enough to reduce the amount of clipping. The highlight clipping warning, which marks burnt-out highlights in red, shows the effect clearly, even if the effect on the actual pictures looks subtle.

Before Highlight clipping warning

After Improved highlight clipping warning

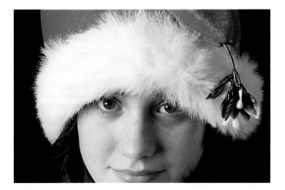

Before

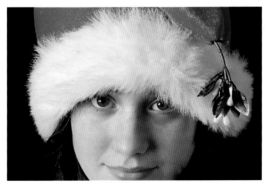

After

WHITE CHRISTMAS
In this studio portrait, the Shadows/Highlights tool has been used to provide more detail in the white fur material around the hat. By applying the adjustment as a Smart Filter, the effect can be turned off and on even after further editing. The effect can be removed selectively from certain areas by painting over the mask.

Selective adjustments

Many of the adjustments that are made to an image in post-production can be made to the whole image area, but it is often preferable, and sometimes essential, to make the alterations only to the areas that actually need it. For instance, altering the exposure or contrast may make a distracting detail in the background more visible if it is applied across the image. Similarly, subtle color boosts aimed at particular areas of the image can frequently create nasty side-effects in other places if applied globally.

Fortunately, Photoshop and most other manipulation applications provide a variety of different techniques with which to make adjustments to just part of the picture.

The most basic of these is to select the area you want to work on, before you make the adjustment. Using a lasso tool, for instance, you can pick out the eyes in a portrait before boosting the intensity of the iris color. But the

trouble with this approach is that it leaves little scope for error and later correction. Do it this way, and it is harder and more time consuming to change the intensity if you decide the adjustment is not strong enough, is unnecessary, or has been applied to the wrong area.

Therefore, the best technique to use is to apply the adjustment as a separate layer. Each new layer can be given a mask, which is transparent as default (appearing white in the Layers palette), but if you paint on this mask in black, it prevents the painted part of the image being affected by the alteration. Better still, paint in a shade of gray (a percentage of pure black), and you can apply the effect in varying amounts to different parts of the image. You can switch the whole mask using the keyboard shortcuts ⌥/alt+⌫/delete or ⌘/ctrl+⌫/delete (one turns the mask white, the other black, depending on which is your current foreground

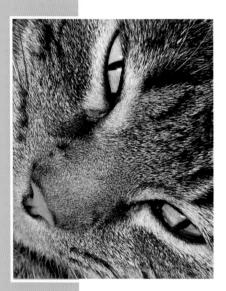

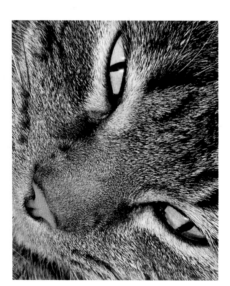

SELECTIVE DESATURATION
In this image, a hand-painted effect is achieved by using the Hue/Saturation adjustment. Parts of the image are made more black-and-white than others by using the History Brush to apply the desaturation in varying degrees.

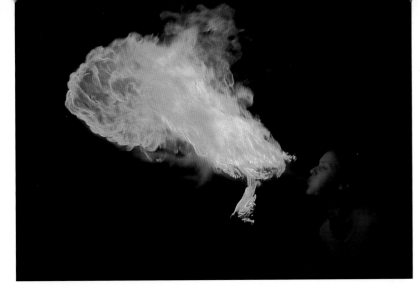

Before

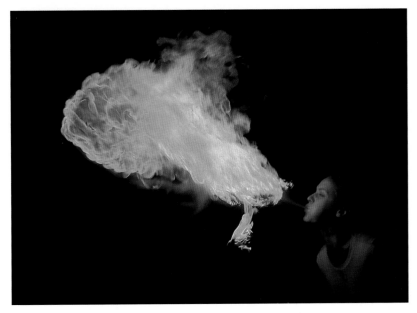

After

FIRE STARTER

In this shot of a firebreather, the use of flash ensures that the woman's face and body are not completely lost in shadow. However, in comparison with the fireball, this area of the image is still dark. A Curves adjustment was used to raise the brightness, and a mask painted so that it only had an effect in the area it was needed. The same mask was then copied when applying a Selective Color adjustment to the area.

The Layers palette showing the masks in the two adjustment layers

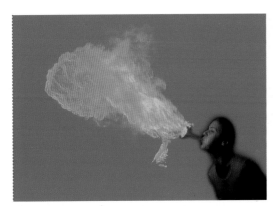

The Quick Mask mode provides a very immediate way of seeing where the mask is in relation to the actual image.

color). With the whole mask black, you can then paint on the effect selectively.

By using a mask, you can turn the effect on and off simply by disabling the layer, which allows you to see and judge the improvement. You can also go back and tweak the mask later, even in years to come if you save a copy of the image with its layers intact.

Another way of making selective adjustments is to use the History palette. Essentially, you can apply filters or adjustments to the whole image, make several undos to the work, and then paint it back using the History Brush tool in the areas where you actually need it. The opacity of this brush is variable, so the effect can be applied more lightly in some areas than others.

It is also possible to convert the background image to a Smart Object in Photoshop CS3, which creates a kind of virtual layer. This layer can have multiple filters applied to it and can be masked like any other, but it can also be switched on and off like other layers, and a mask serves a similar function to the History Brush.

Cosmetic surgery

Cloning allows digital photographers to create a more photogenic version of reality. With a few clicks of the mouse, garbage can be removed from landscapes, cables can be removed from cityscapes, and blemishes can be removed from a person's face.

The ability to remove pixels from an image is particularly important in flash photography. Flash can often create unsightly specular highlights that can be removed or suppressed with judicious use of the Clone Stamp tool.

Flash also has the unwelcome tendency to reveal every spot of dust and defect on an object. This is a particular problem in product photography, where an extensive depth of field and dark-toned subjects can show up dirt and marks with much more clarity than your camera screen would suggest.

While black backdrops and dark objects act as dust magnets, white backgrounds and light-colored subjects can prove just as difficult. The bright tones commonly used in studio photography, coupled with small apertures mean that every speck of dust on an SLR's sensor becomes a black fuzzy blob in the image. This dust is invisible and unproblematic with most photographic subjects, but sometimes it needs to be laboriously cloned out.

The Clone Stamp tool is undoubtedly the best all-round tool for this touch-up work, but the alternative Healing Brush tool can give good results, and is particularly useful when working with the gradated tones of skies or faces, even though its effectiveness is less predictable.

Whichever tool is used, it is important to clone while viewing the image at 100% magnification so you are seeing every pixel in the picture. However, you should periodically zoom out, so you can see whether your handiwork remains unnoticeable. It is a matter of retouching a small area, then looking to see whether the correction is invisible. If it is not, undo the correction (or go back several steps in the History palette) and try again.

The Clone Stamp tool is used at 100% opacity, with soft feathered edges for most corrections, using nearby areas to completely conceal dust marks and the like. However, changing the blending mode from Normal to either Darken or Lighten helps to minimize the number of pixels

Before—a dusty
black background

The problem seen at
100% magnification

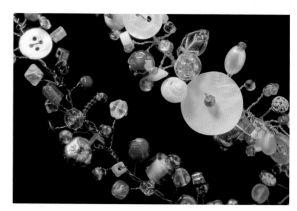

After—clean

TIDYING THE VELVET
Keeping black velvet free from fluff and dirt is virtually impossible. However, these light colored specks are easy to remove with the Clone Stamp tool set to Darken at 100% opacity. Ensure the paintbrush size is slightly larger than the flecks you are dealing with.

that are changed. Use the Darken mode to remove light colored dust from the surface of a black subject, and the Lighten mode to remove dark marks from a light backdrop.

There are some faults that you do not want to remove completely, however. Specular highlights created by flash can be reduced in size using cloning, but removing them completely can make the image look flat and unnatural.

GLOWING SMILE

Despite using bounce flash, there are bright reflections, most noticeably on the end of the nose and chin. These were softened using the Clone Stamp in Darken mode set to an opacity of 25%.

Retouching is done on a separate layer, so the corrections can be undone easily at any stage.

Before

After

Clone Stamp tool settings

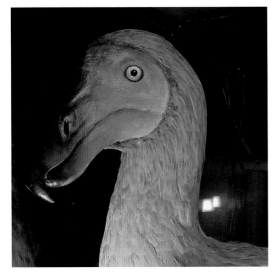

Before

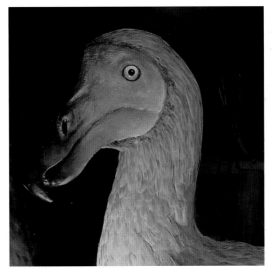

After

PLIGHT OF THE DODO

Behind a glass case, it was impossible to photograph this museum piece well without reflections from the wireless off-camera flash appearing in the shot. However, with some patience it was possible to paint the bright highlights out, despite it being hard to find clone source areas.

With complex retouching, it is best to clone on a new layer rather than directly onto the background image.

Larger highlight areas such as the "shine" created by flash reflecting from a person's skin can be toned down by cloning nearby unaffected areas using the Clone Stamp at a lower opacity in Darken mode. Set the Clone Stamp to 20% or so, then slowly paint until the skin's glow is subdued. A similar technique can be used to reduce wrinkles and other skin blemishes. If you use the Clone Stamp tool set to Lighten at a low opacity, unwanted facial lines can be softened without changing the subject's features. Such corrections can be justified as simply a necessary way of making up for the shortcomings of using flash.

Cleaning up the background

In the ideal studio there is always plenty of space. The backgrounds are big enough so you can use any zoom setting you like without running out of canvas, and there is enough space between the subject and backdrop to allow both to be lit independently.

But in reality, most photographers have to make do with the space available, and this means compromising. You may not be able to position the backdrop far enough back to light it separately, and even if you use every inch of the backdrop you may still have problems fitting the whole

subject in with the wide-angle lens you wanted to use. If you know just what can be achieved in post-production, however, you will be able to get away with a less than perfect studio setup.

Unwanted creases in a backdrop, can be cloned out easily, and the brightness of the background can also be altered. White backgrounds are a particular problem for those with small studios, and it is often impossible to get them to record with the right degree of brightness and color neutrality across the whole area, while still making

Original

WHITE OUT
A colorful tissue box, shot to illustrate shapes in a kindergarten textbook. Although the lighting on the cube is good, the white background is discolored in some areas. This is corrected using two layers. The first is a Curves adjustment to the background alone, then a Selective Color adjustment to make final changes to the color and brightness.

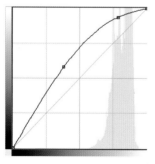

A mask shape for the Curves layer was created using the Polygonal Lasso tool.

Curves adjustment

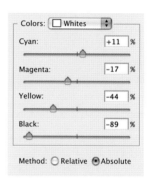

Selective Color adjustment settings

Final

sure that the subject is perfectly exposed. Whitening and brightening the background may sometimes be simply achieved using cloning techniques, but it may be necessary to make a selective adjustment to the exposure, contrast, or color, using a mask to avoid any unwanted effect on the subject itself.

A useful tool for doing this is Photoshop's Selective Color adjustment, which can be applied as an adjustment layer. This allows you to alter the white elements within the image without affecting other tones and colors. It provides a good starting point for removing a color cast from a white backdrop, and features a separate Black slider to alter brightness. An advantage of this approach is that usually very little, if any, of the subject needs masking, making it a quick and easy way to create a cutout-style image.

Depending on the severity of the problem, a selective Curves adjustment may also be needed. The mask can be handpainted, but normally it is easier to use one of the Lasso tools to draw around the subject, and then invert the selection.

VIRTUAL BACKGROUND

I want to shoot this old oilcan (below) on a pair of painted metallic boxes. But the area they provided was not big enough to cover the picture area, and there was a visible join between the two. The picture was taken anyway, and the Clone Stamp tool was used to hide the gap, and fill in the missing corners of the background.

Once this was done, it was possible to make an alternative version with a much larger area of empty backdrop. The image area was extended using the Canvas Size command, and this new area was then populated with cloned pixels.

EXTENDING THE CANVAS

Not having enough background space to work with can mean that some camera angles seem impossible to achieve. Low-level camera heights, or even full-figure portraits, can mean that parts of the studio wall or ceiling encroach into the image area. Even photographers with larger studios, or who specialize in smaller subjects, have backdrops they would like to use that are often not quite big enough.

However, with plain or repeating backdrops, it is relatively easy to extend their size in post-production. Using cloning techniques, you can paint over areas where your chosen background did not quite reach. All you have to do is to make sure the subject is well within the frame.

Being able to clean up the background in this way allows more scope for cropping because you can rotate the selected area without fear of running out of room.

It is also possible to extend the bounds of the picture itself in post-production. This can provide extra space, giving your subject more space to "breathe" if they were shot rather too close to the edge of the frame.

Original

Canvas Size dialog

After Canvas increase

Cloned

Final

Removing redeye

Once you appreciate the factors that cause redeye in low-light flash portraits, it is a curse that is relatively easy to avoid. However, there are times when the flash equipment that you have available, or the unavoidable distance of the subject, means that it can spoil what is an otherwise successful shot. Candid shots are a particular difficulty, as are people in the background of a shot, whose existence you could not or did not plan for.

Although the bright red color causes an annoying distraction even if the peoples' eyes occupy a very small area of the frame, these can be made to look a normal color in post production.

As with all photo manipulation, there are a variety of ways of turning the pupils from red to their more usual shade of black.

All versions of Photoshop, including Elements, have a semi-automated system for correcting the coloration. You

Before

Replace Color dialog

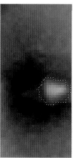

Selecting the pupils

REPLACE COLOR

This shot of a bellydancer was taken with built-in flash and a focal length of 300 mm, creating strong redeye. To remove this, the eye areas were selected using the Lasso tool, then the Replace Color adjustment was used to change the hue and darkness of the pupils. Two views of the image, at different magnifications, were used simultaneously to ensure that the transformation was convincing in closeup and at a distance.

After

simply click on, or draw around, the offending section of the image and the red patch is recolored for you. Photoshop Elements gives some control over the effect and it is worth experimenting with different settings so you get a natural-looking image. An alternative method is to use the Replace Color command (Photoshop only).

First you need to select the area of the eye reasonably precisely. Use the Lasso tool to draw around the outside of the red pupil (or pupils), so the problem area is encircled. The next part of the process is much easier if you have two windows showing the image you are working on—one showing the pupil at the highest possible magnification, and the other giving an overall view of the face. Additional views can be opened by following the *Window > Arrange > New Window for....* menu path.

With a global and detailed view you can then use the Replace Color command. By altering the hue, and reducing the saturation and lightness, you can create a convincingly dark pupil, while you can refine your selection using the fuzziness and pipette controls.

SHARPENING

All digital pictures require a certain amount of sharpening, as the sensors are constructed in a way that will naturally create a slightly soft image. Although the camera can do this sharpening for you, it is best to do it in post-production as images need different amounts of sharpening depending on subject matter, their intended use, and the aperture employed.

Flash pictures need particular care when being sharpened, as the bright specular highlights can end up looking more pronounced than you would like them to.

Conversely, the very small apertures frequently used with flash often mean that the image looks softer than usual—at such apertures lenses don't produce the best resolution, due to an effect called diffraction. This means that more digital sharpening is useful for pulling out detail from the image.

The solution is often to apply the sharpening selectively. The most usual sharpening tool is the USM (Unsharp Mask) filter. This can be applied as a Smart Filter, so you can apply sharpening at the extent needed in areas where it is required most. A mask can then be painted to remove, or to reduce, the sharpening from areas or details of the image where sharpening is not required, or where it creates unwanted artifacts.

Without USM

Unsharp mask dialog box

Applying USM as a Smart Filter allows you to edit the amount of sharpening, and use it with an editable mask.

With USM

SELECTIVE SHARPENING

This flower shot, taken with fill flash, needs a good degree of sharpening to reveal detail in the central circle. But this degree of USM is not needed anywhere. A mask is used to remove the effect from the bright reflections of the flash in droplets of water on the petals, and from the leafy background.

Correcting for mixed lighting

Unless filtered, flash units provide light with a color temperature that is similar to that of daylight. Unfortunately, flash is not always used in daylight hours. In fact, for most users, it is most frequently used in lowlight conditions, where the scene is partially lit by a variety of artificial light sources that have a completely different color temperature. The result is that the areas not lit by the flash have eerie color casts. Fluorescent strip lights create backgrounds with a green tinge, while tungsten lighting gives an orange tint to the shot. The longer the shutter speed used with flash, the more noticeable this discoloration becomes.

The effect of mixed lighting is not always unwanted. However, although unbalanced color can be visually interesting when using slow sync flash, the effect often needs to be tamed in post-production. In other situations, you will want to do your best to get rid of any color cast that has found its way into your picture.

In these situations, making a global correction to the color or the white balance has no advantage, as this will also change the color of the flash-lit subject. Instead, the color needs to be adjusted selectively.

Before

After

Selective Color adjustment

FLUORESCENT GLOW

For this brightly lit seafront kiosk, flash is used simply to avoid the faces being too dark. However, the strip lighting behind creates a green tinge to a large area of the image. This was corrected, without the need for the mask, using the Selective Color adjustment. Rather than altering the green controls themselves, the best result was obtained by reducing green (and increasing magenta) in the yellow channel.

with slow shutter speeds, and also known as second-curtain sync.

Redeye Effect often caused by flash where light reflects from the retina, illuminating blood vessels in the subjects eye—producing a red-colored pupil in the image.

Reflected light reading The most usual type of exposure meter reading, where the amount of light reflecting off a subject is measured. An alternative approach is to use an incident light meter.

Rim lighting Backlighting where the edges of the subject are illuminated in such a way to create a halo-like effect.

Ring flash Flash lighting system that uses a circular flash tube that attaches to the front of the lens to provide even, shadowless lighting.

Scrim Material placed in front of a light source to diffuse it.

Second-curtain sync Another name for rear-curtain sync.

Slave Device that triggers a flash unit automatically when another flash is fired. The slave uses a light-sensitive photoelectric cell, and cuts down on the number of wires needed in a studio.

Slow-sync flash Technique where a slow shutter speed is used in conjunction with flash. The flash will usually provide the main source of illumination, but the ambient light creates a secondary image that can be useful for suggesting movement, or for providing detail in a background that would otherwise have looked unnaturally dark.

SLR (single lens reflex) See dSLR.

Snoot Cone- or cylinder-shaped lighting accessory fitted to studio lights to restrict the spread of light.

Softbox Lighting accessory fitted to studio lights in order to diffuse the illumination. Usually square, octagonal, or rectangular in shape and produces even lighting over a limited area.

Stop A unit of exposure. Changing exposure by a single stop is equivalent to doubling or halving the amount of light reaching the image sensor. The distance between each of the standard aperture settings ($f2.8$, $f4$, $f5.6$, $f8$, etc.) is considered to be a full exposure stop.

Stop down To close down the aperture.

Strobe Alternative term for a flash unit. Can, confusingly, also be used to describe a flash effect, where light flashes on and off in rapid succession.

Sync speed The fastest shutter speed that can be set on a camera that allows synchronization with the flash. See flash synchronization.

Synchro sun See Fill flash.

TTL (through the lens) metering Exposure system in which the intensity of light is measured through the camera lens.

Umbrella Umbrella-like reflector that attaches to a studio light. It produces soft lighting over a wide area. Some umbrellas can also be used as diffusers. It's not uncommon for British photographers to use the colloquial term "Brollies" to describe these.

Vignetting Darkening of the corners of an image, normally due to lens falloff. Can be corrected by using digital manipulation tools.

White balance Digital camera system that sets the color temperature for the scene being photographed. This can be set automatically, with the system trying to set the color so that it looks normal to the human eye, or manually.

Zoom burst Special effect where the angle of view of a zoom lens is changed during exposure, creating blurred radial lines across the picture.

Zoom ratio Relationship between the shortest and longest focal length settings on a zoom lens. A 28–140 mm lens has a zoom ratio of 5:1 or 5×.

Index

ACKNOWLEDGMENTS

The author would like to thank for following for assistance in the preparation of this book:

For lending equipment:
Chris Coleman @ Newpro
Graham Armitage @ Sigma Imaging
Roger Massey

For providing product photography:
Bogen Imaging, Bowens International, Broncolor, Canon, Elinchrom, Interfit, JTL, Kaiser, Kodak, Lastolite, Manfrotto, Mumford Micro Systems, Nikon, Olympus, Pentax, Quantum, Sekonic, Sony.

For modeling, or for providing props and locations, for photographs in this book:
Ethan Kinsler, Ant Nicholls @ Kiss 101, Massey family, Boxall family, Sharon & Lucy Churchill, Fiona Byrom, Kate King, Amy & Di Webster, Jason Eacott, Rob & Lynn Cooke, Ian Rogers, Jessica Fox-Taylor, Lesley McGregor, Allie @ The Painted Home, Sarah & Nick Utili, Charmaine Croker, Leif Hadfield, Ray & Andy George, Harry Cornish, Toby Drew, Alexander Fisken.

For continual support and assistance:
Rachel, Joseph, Gabrielle, Patrick & Lucia George

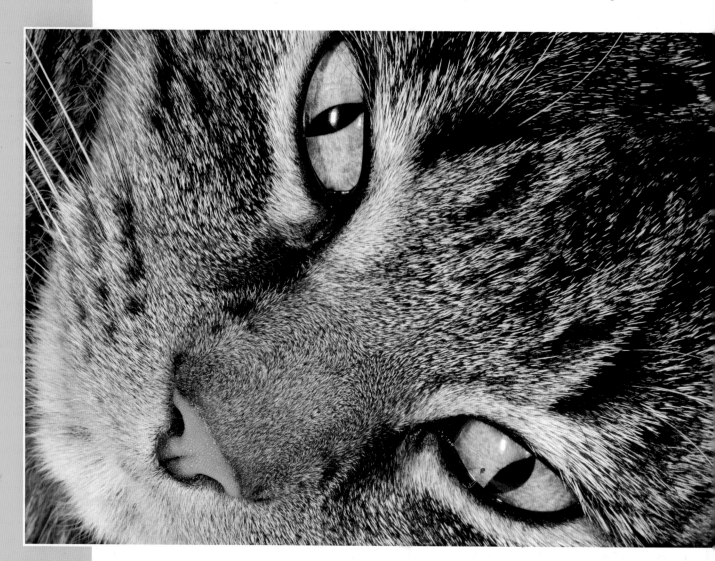